D0769467

New York Waters

Profiles from the Edge

By Ben Gibberd
Photographs by Randy Duchaine

The
Globe
Pequot
Press

GUILFORD, CONNECTICUT

To buy books in quantity for corporate use
or incentives, call **(800) 962–0973**
or e-mail **premiums@GlobePequot.com.**

Text copyright © 2007 Ben Gibberd
Photographs copyright © 2007 Randy Duchaine

All rights reserved. No part of this book may be reproduced or transmitted in any form by any means, electronic or mechanical, including photocopying and recording, or by any information storage and retrieval system, except as may be expressly permitted by the 1976 Copyright Act or by the publisher. Requests for permission should be made in writing to The Globe Pequot Press, P.O. Box 480, Guilford, Connecticut 06437.

The Globe Pequot Press is a division of Morris Book Publishing, LLC.

Text design by Casey Shain

Library of Congress Cataloging-in-Publication Data
Gibberd, Ben.
 New York waters: profiles from the edge/by Ben Gibberd; photographs by Randy Duchaine. —1st ed.
 p. cm.
 ISBN-13: 978-0-7627-4133-5
 ISBN-10: 0-7627-4133-3
 1. New York (N.Y.)—Biography. 2. New York (N.Y.)—Biography—Pictorial works.
3. Waterfronts—New York (State)—New York . 4. Rivers—New York (State)—New York .
5. River life—New York (State)—New York . 6. Community life—New York (State)—
New York. 7. New York (N.Y.)—Social life and customs. 8. Waterfronts—New York
(State)—New York—Pictorial works. 9. Rivers—New York (State)—New York—Pictorial
works. 10. New York (N.Y.)—Pictorial works. I. Duchaine, Randy. II. Title.
 F128.25.G53 2007
 974.7'1—dc22
 2006033036

Manufactured in China
First Edition/First Printing

This book originated from an idea by the book and magazine designer Sam Antupit (1932–2003), who was responsible for bringing together its author and photographer. Without Sam's initial enthusiasm this record of urban life would not have been possible, and it is gratefully dedicated to his memory. Our deep thanks to Sam's widow, Rollie, who generously allowed us to continue with the project under different hands.

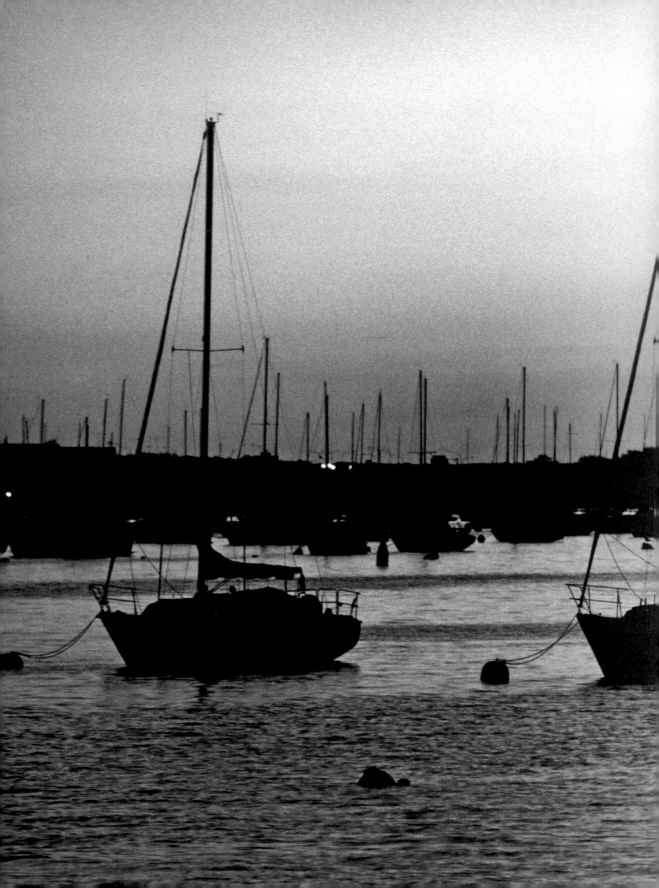

CONTENTS

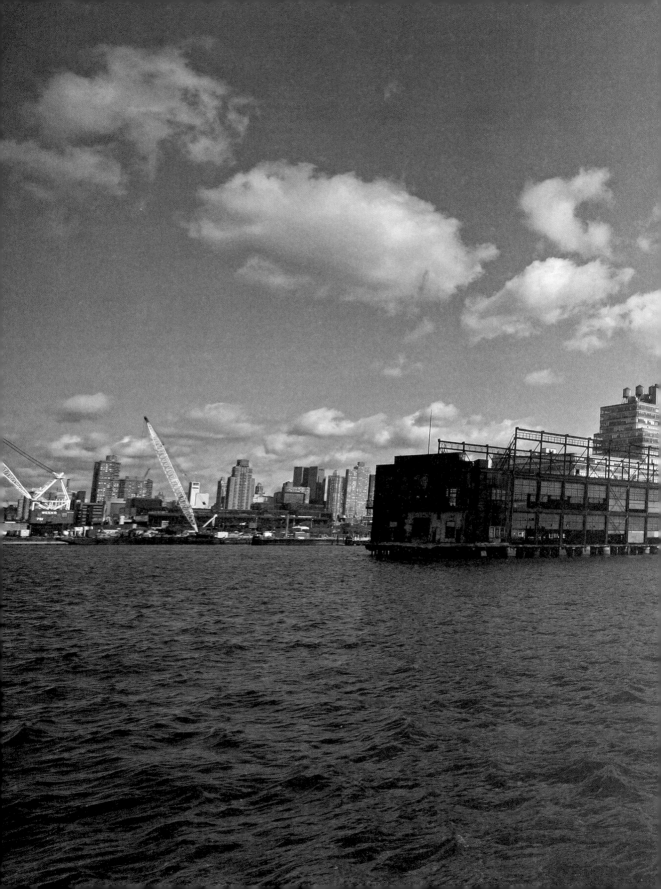

ACKNOWLEDGMENTS

Many people provided invaluable service during this book's gestation. Duncan Ball volunteered as a camera assistant on numerous assignments; Tom Wallace, a literary agent of the old school in the best sense of the term, offered sage advice; Robert Maass provided inspiration with his delightful film *Gotham Fish Tales,* the source of several of our subjects; and the Writers Room supplied, as always, a sanctuary. We also would like to thank our families, who put up with endless research and waterfront trips—to Susan and Jana, and Nina and Jack.

INTRODUCTION

A waterfront, by definition, is the most amorphous of subjects. Where do you begin, and where do you end? What do you put in, and what do you leave out? The water mocks such arbitrary appellations as "river," "estuary," "bay," "sound," and "harbor," being all of these yet none of them alone. To even call a book *New York Waters* is misleading, given that New York's waters are also those of New Jersey and Long Island and the Hudson River Valley, to name only a few.

But a book needs boundaries, and so reluctantly we made some, keeping our subjects, by and large, within sight of New York City.

Even with this limitation, we had too many subjects to profile in too few pages and therefore had to exclude many remarkable men and women. They include Dan Mundy of the environmentalist group Eco-Watchers in Beach Channel, Queens, who keeps a beady eye on the fast-disappearing marshland of Jamaica Bay; Joy Garland of the Stuyvesant Cove Park Association, who dedicatedly maintains one of the loveliest waterfront parks in Manhattan; groups such as Baykeeper and Riverkeeper, guardians of our waterfront heritage; and Sunny Balzano, owner of the eponymous Sunny's Bar in Red Hook, Brooklyn, and guardian of another kind of culture entirely. Their very abundance, though, is encouraging and testament to the human richness of this city.

What we hope to convey in these pages is the sense of passion and commitment that animates each of the people we have profiled. From Olga Bloom, who tore up everything in her life to start a floating chamber music venue on an old coffee-bean barge in the East River, to the Seamans, a father and son who practice the ancient profession of eel fishing in Jamaica Bay despite ever-growing official antipathy, the people in this book have not chosen the normal

or easy path in life; instead, they have "followed their bliss," to use that shopworn but still relevant phrase from Joseph Campbell.

Unfortunately, the New York City waterfront is becoming an increasingly difficult place in which to lead an unorthodox, or even faintly nonmainstream, lifestyle these days. One of the sadder realizations of creating this book has been that, in a few years, many of the people profiled may no longer be doing what they do. The rapacious demand for waterfront real estate has already closed one of the businesses featured here, Mike Gallagher's New York Shipyards (its buildings have been razed to make way for an IKEA). Even the owners of thriving maritime businesses, such as McAllister Towing and Caddell Dry Dock, admit that the metropolitan-area waterfront is becoming a tougher and tougher place in which to conduct business.

But this book is not a gloomy one; there's too much life in it for that, and its subjects are too engaging. As long as there are people around like Phil Frabosilo, ready to park his yellow taxicab and drop a line laden with spark plugs into the East River at the drop of a hat, or David Sharps, who spent four years pumping mud out of a sunken barge and repairing her as a living-history lesson for all, things will probably still be all right.

■　　■　　■　　■

Special Note: The following profiles were written and photographs taken over a period of nearly five years, between 2002 and 2006. Although the circumstances of some people and companies have changed in the interim, we thought it important to preserve these particular moments in time. When necessary, we have provided a brief update at the end of selected profiles.

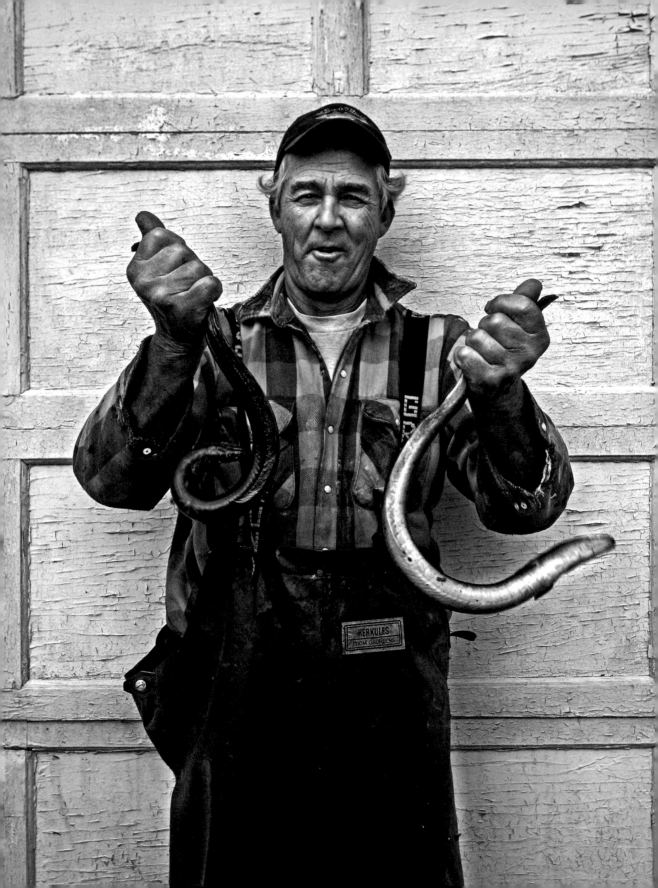

LARRY SEAMAN SR.

Eel Fisherman

Follow Rockaway Boulevard as it curves around the seemingly endless northern boundary of JFK airport until you reach the very edge of the city. It's a low-lying world of scrub and marshland and chain-link fencing, with the occasional strip mall or radar tower offering what little elevation there is. Planes swoop in to land, fat-bellied and frighteningly unaerodynamic at this close vantage point. Less than a hundred yards before Queens peters out into Nassau County is a small hand-lettered sign, tacked to a telegraph pole, that simply says BAIT.

Turn off here, and suddenly you are in a landscape that would not seem out of place in Florida or the deep South, except for the cold wind blowing off Jamaica Bay. Small shingle houses cluster around a loop of unmarked road, their backs facing a creek with a long wooden dock running along its edge. There are pickup trucks and boats in the driveways; a few dogs bark halfheartedly. This is where Larry Seaman and his son, Larry Jr., the last two full-time eel fisher-men in New York City, pursue their lonely occupation.

Seaman Sr. is slim and in his mid-sixties; he wears a blue checkered shirt and waders that come halfway up his chest. His face is suitably rugged for such a profession, buffed by a lifetime of exposure to sun and wind, and his Queens accent has a touch of something ancient in it that's hard to pin down. "I love it out here," he says simply. "It's beautiful. Any time of year, any weather." The sentiment is echoed by his son, a powerfully built thirty-year-old in a hunting jacket standing next to him on the dock beside a pile of handmade wire-mesh traps. "I wouldn't give it up for anything," he says. "I love it, and I love working with him, you know? There's not too many people get to work with their fathers."

It's not an easy life. Father and son are usually both up by 5:00 A.M. seven days a week to prepare the traps, and they are on the water by 7:00 or 8:00 A.M., depending on whether they have eel deliveries to make first. Their flat-bottomed wooden boat is small, offering no shelter, and is loaded with traps and the large plastic barrels into which they dump the captured eels. Propelled by a 150-horsepower outboard motor, they glide out each morning into the vast 9,000-acre mosaic of water and yellow-green marshland that falls away to the city's southern edge. The charmingly archaic names of this environment— Big Egg Marsh, Pumpkin Patch Marsh, Yellow Bar Hassock—seem a gentle rebuke to Manhattan's modernity, shimmering in the distance.

It takes about five hours to yank up, empty out, and rebait the Seamans' seventy or so pots with a section of horseshoe crab ("It's like lobster to us, horseshoe crab to an eel," the elder fisherman says). If a pot is empty or contains only a few eels, they might move its location elsewhere. It's hard work on the back and arms, though not as tough as what local clammers— who wrench their prize from 30 feet of water off Staten Island or Sandy Hook in New Jersey, about three times the average depth of Jamaica Bay—have to endure, Seaman Sr. is quick to point out.

In a low-lying world of scrub and marshland and chain-link fencing, Larry Seaman and his son pursue their lonely occupation.

For him this world is as familiar as Midtown's streets are to a cabdriver, and probably more so. He knows not only the contours of every marsh and inlet in Jamaica Bay from Hook Creek (the tiny inlet his house is on) to the

Marine Parkway Bridge nearly 9 miles to the west, but also the contours that lie beneath the water. "I know every bump and dip," he says. "I could draw a map of it as good as the Geodesic survey they do." In winter in particular, when the eels take refuge in the thick mud at the bottom of the bay and the Seamans switch from pots to eel combs, dragging their catch out of hideaways with specially made devices, this is invaluable information.

The Seamans catch two types of eels: bait eels, 16 inches long or less, which they sell mostly to charter boats for fishing, and larger eels that weigh up to about four pounds and are 2 to 2.5 feet long, which they sell to local fish markets. When Seaman Sr. first started out in the late 1950s, 25 cents a pound was the going price; eels now fetch between $3.50 and $4.00 a pound. At Christmas, when demand peaks, especially from New York's Asian community, the price goes up to $5.00 a pound. Seaman Sr. fondly recalls his first big customer, a smoked-eel joint on Cross Bay Boulevard called the Kettle of Fish (now a swimming pool and spa store) that used to take all he could catch. "That's how I fed my family," he says. "That's how I bought my first house."

During the warmer months, until about the first week of January, the Seamans keep their captured eels in large wooden bins hung over the edge of their dock. (All eels caught in the winter have to be sold the same day, as ice or snow will kill them.) Each storage bin weighs about 500 pounds, and with fierce effort father and son drag one out of the water. Seaman Sr. pulls open the lid with a flourish, and there they are in all their collective fury—a seething mess of black and silver bodies churning up a glutinous foam. He inserts an enormous fist and plucks one out, holding it in a pincer grip between thumb and index finger just below the head. The vehemence with which the eel thrashes is disturbing, as though it is more affronted by such human liberty than fearful of its fate.

Seaman smiles. "They don't say 'slippery as an eel' for nothing," he says. "Go on, stick your hand in." Unlike snakes, eels are covered in slime, though the real unpleasantness in holding them lies less in their texture than in their primeval otherness—the sense that they don't belong to the world of living things we are familiar with. Seaman Sr. says that their slime has natural antibiotic

properties and as proof holds out his hands for inspection; they are devoid of any nick or infection even after a lifetime of outdoors work.

The larger eels are silver in color, the smaller ones black or green. The "silvers" are preparing to head back out to the Mediterranean to spawn, Seaman Sr. explains. He points out the eye size of the specimen he is holding. "See how big his eyes are? The eyes get bigger for traveling the ocean with safety, to watch out for the predators." Seaman slaps the eel into a scale like a bunch of fruit and notes with satisfaction that he's close to three pounds.

Such a life, hard as it is, may seem positively carefree compared to the cubicle-ridden wretchedness of many a New Yorker, but the Seamans are under a considerable degree of stress. Not only is theirs a dying profession—there are probably no more than one hundred full-time eelers left between Florida and Maine (there used to be hundreds in New York Harbor and Long Island alone, Seaman Sr. estimates)—but father and son are the subject of ever-increasing antipathy from officialdom. The Wildlife Conservation Society, or "Constipation Society," as the Seamans have dubbed it, have deemed both the eel and horseshoe crab population of Jamaica Bay threatened, a position Seaman Sr. bluntly claims is "bullshit, pure bullshit."

"There's only us and about three or four part-timers—and I know the names of each one of them—who are catching eels," he says angrily. "And we're catching more now than we've caught in the last five years. More small ones, and more big ones. So, I mean, where the hell's the shortage?" The same plenitude applies to horseshoe crabs: "You go down to Barren Island"—a part of Floyd Bennett Field on Brooklyn's shoreline—"or back behind the Statue of Liberty on a full moon and look along them beaches there, and there's more crabs than you can imagine. Twenty thousand or more piled on top of each other. It's unbelievable." Seaman Sr. suspects that, apart from "bad science" in calculating the numbers, the real reason horseshoe crabs are protected is that their proteins have been shown to have potential medical applications. "But we don't have no voice," he says. "We don't have a college education, we didn't study marine biology, so what do we know?"

One direct consequence of the controversy is that to ensure that they do not fall foul of the law, the Seamans are forced to go to Freeport in Long Island to purchase crabs at $3.00 apiece. They once halved the horseshoes for bait traps; now they parsimoniously quarter them. But perhaps what most upsets the men is the idea that they have been branded as uninformed and destructive of the environment they love. As Seaman Sr. points out, nobody knows Jamaica Bay better than himself and his son: "We see its tiniest change from day to day, depending on the weather. And both of us are conservationists—after all, we have to keep ourselves in check; otherwise we'd put ourselves out of business."

September 11, 2001, also was not kind to the Seamans, resulting in "a paranoia," as Seaman Sr. puts it, with serious consequences for their business. Buoys have been established around the edge of the airport, helicopters regularly fly overhead, and the Coast Guard in particular keeps a suspicious eye on everyone. All of which is fine, the Seamans say, except for the fact that they are now in the absurd position of been treated as suspects by people with whom they have been on a first-name basis for years. "It's not the regular guys," says Seaman Jr. "It's the command structure; they're just so gun-shy about everything."

Seaman Sr. recalls with a grimace a recent trip with a *New York Times* reporter and photographer who were doing a story on him. "All of a sudden a Port Authority boat comes up to me and goes, 'Larry, they want to talk to you,'" he says. Seaman and the reporters were taken ashore to the waiting police and told that they had "breached a security zone." Seaman was indignant. "I got my first piece of ass on that beach when I was sixteen, so don't tell me about breaching no security zone!" he shot back. The Coast Guard was unamused and proceeded to arrest him, threaten him with a $50,000 fine, and hold him overnight. Finding nothing else on the *Times* reporter, they charged him with failing to pay an old ticket for cycling on the sidewalk. "I mean, if that ain't *bullshit,* what is?" Seaman Sr. asks, laughing bleakly.

The Seamans' kitchen is large and gloomy, with dark faux-wood paneling and a yellow plastic tablecloth. The place is not untidy, but a woman's touch is clearly absent. Lois, the wife and mother in this household, died of liver cancer in

1998. Although he has a girlfriend in Virginia, Seaman Sr. still shows palpable sadness when he talks about his late wife. "I remember when I came out of the hospital after identifying her," he says. "I couldn't believe people were still walking around, cars and buses moving and everything. I felt everything should all be still because she had died." Seaman didn't know what to do and languished at home until a fellow fisherman advised him that he should simply get up and go eeling again. The advice was "absolutely right," he says. Seaman Jr. is likewise without his wife: She left him recently, taking their son, Michael, with her back to Connecticut. An album of family photos lies on the table, containing pictures of Seaman Sr. and his wife on their wedding day and of Seaman Jr. playing with his son.

Do they eat eels themselves? The question makes the men laugh. "Anything that can wriggle when it's dead isn't going in my stomach," says Seaman Jr. "But my Dad, he loves them." This reminds Seaman Sr. about his wife's squeamishness when it came to eels. She hated the way they squirmed, even after they were dead and skinned; she wouldn't touch them until the muscular contractions had stopped. As a joke, Seaman would wait until her back was turned and then sprinkle salt onto the sliced-up pieces, which would cause them to contract frantically. "Oh God! It used to absolutely freak her out!" he says. Both father and son crack up.

For now the Seamans will continue to do what they have done all their lives, but both are aware they might soon become just another part of New York's maritime past, especially with recent talk about a complete moratorium on all eeling and crabbing in Jamaica Bay. "I told my dad the other day, I'll eel until they put me in jail," says Seaman Jr. defiantly. His father responds quietly, "Yeah, but they will. That's the problem."

■　　■　　■　　■

The Seamans are still awaiting a decision from the Department of Environmental Protection as to whether Jamaica Bay will be entirely closed to commercial fishing.

RICH NARUSZEWICZ

Ferryboat Captain

Captain Rich Naruszewicz is a pilot for New York Fast Ferry, a passenger ferry service that operates between Highlands, New Jersey, and downtown Manhattan. He's been involved in one maritime business or another since he was seventeen, when he began work as a cook on a tugboat. Later, he filled in as a deckhand and painter before doing a twenty-year stint as a tankerman for Texaco, transporting gasoline from such places as the Gulf of Mexico to New York Harbor. "I've done all kinds of stuff," he says modestly when asked about it, "a bit of this, a bit of that."

This modesty extends to his job as captain on *The Finest* and *The Bravest*—two of New York Fast Ferry's vessels. "If you can play Nintendo, you can do this," Naruszewicz says, sitting in the vast leather swivel chair of *The Bravest's* wheelhouse, surrounded by an array of instrument panels and blinking display screens. By his right hand is a small black joystick, about the size of a coffee cup, with which he controls the ninety-six-ton, twin V-16 turbo engine vessel. Casually he plays with the joystick, pushing it slightly back and forth. "Basically, whichever way the arrow's pointing, that's where the bow's gonna go," he says. "If you want to walk the boat sideways, the boat will walk sideways for you."

A sharp beep of protest rises from the control panel. Naruszewicz's fleshy hand reaches out and presses a button, causing it to cease. Everything is automated on his ship, dispelling any romantic notions of crusty seadogs grappling with brass steering wheels and barking orders to their mates. Even the captain's casual attire—jeans, sneakers, and a crumpled sweatshirt with New York Fast Ferry's logo on it—is in keeping with the informal, computer-age feel of things.

"Whichever way the arrow's pointing, that's where the bow's gonna go. If you want to walk the boat sideways, the boat will walk sideways for you."

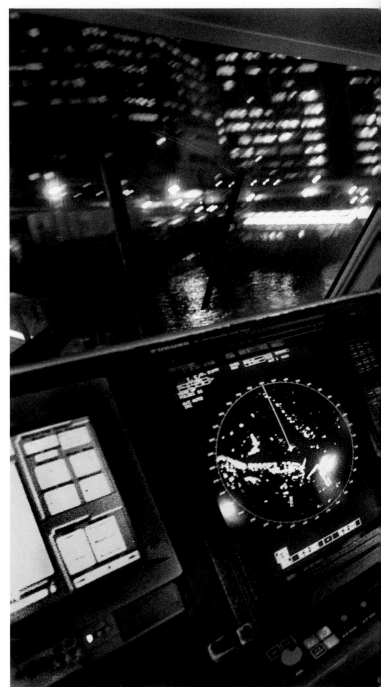

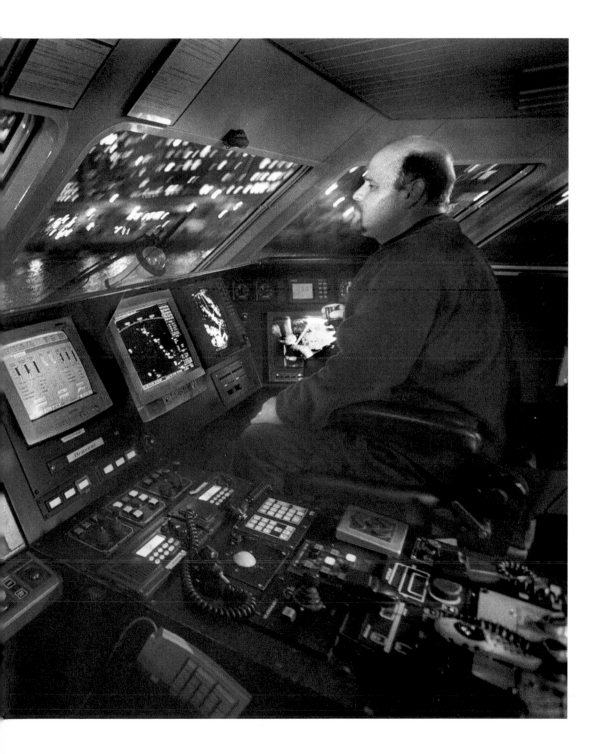

After the crew arrives—Ed, the mate; Bob, the ship's engineer; and two deckhands—Naruszewicz uses the joystick to pull away from the dock, listening to instructions from Ed, who acts as lookout at the stern. In the confines of Brooklyn's Atlantic Basin, the ship dutifully spins around with the economy of a small car. Naruszewicz gently eases the joystick forward, and the boat slides into the East River.

"Vessel Traffic, channel fourteen . . . Yeah, good afternoon, sir," he says, his voice becoming more formal. "We're going to be eastbound East River for 34th Street. We're just checking into your system." Vessel Traffic is the marine equivalent of air traffic control, a vast web of radar and video cameras placed around the harbor at strategic points and controlled from a central operating station on Staten Island. Even though you can't see them, they can see you: "They can tell if you're scratching your balls under the Verrazano Bridge," says Naruszewicz.

"We had to wash down the entire boat with a fire hose because it was all contaminated—pulverized concrete and everything."

As *The Bravest* slides past the deserted shoreline of Governors Island on its way to its first stop, Wall Street's Pier 11, Naruszewicz points out the various ships in the harbor. *Asphalt Glory,* a tanker loaded with tar to be turned into roofing shingles, heads in the opposite direction. Another tanker contains chemical additives for refining petroleum. A tug tows a blue barge full of twisted heaps of metal—scrap from Ground Zero being taken to Fresh Kills. Ironically, a lot of the old sanitation barges have been brought back for this use just a year after their official retirement in March 2001, when Fresh Kills finally closed as a landfill.

As for almost everyone involved in the marine transportation business, September 11, 2001, was a busy day for Naruszewicz. "We'd just left Pier 11 and were going back to Highlands when the first plane hit," he says. "We turned around and got fuel and came right back. We worked twenty-one hours that day, from 4:30 in the morning to 1:30 in the morning. I went home, took a shower, changed clothes, had that much Dewar's"—he indicates a healthy measure—"and came back. We had to wash down the entire boat with a fire hose because it was all contaminated—pulverized concrete and everything. The sides of this boat were black."

For his bravery in sailing into danger to rescue people trapped in Lower Manhattan, Naruszewicz was given the Admiral of the Ocean Sea Award, the most prestigious prize in the transportation and maritime industry. The local paper in Bayonne, where he used to live, ran a picture of him with the award, looking curiously out of place in a suit and tie. Because Naruszewicz doesn't own a suit, he had to rent one especially for the occasion, returning it the same afternoon.

Naruszewicz is proud of the award and considers himself as much a people person in the service industry as a maritime figure. "I like to get along with people. I try to talk to a lot of them, you know? Shake their hand, say, 'Hi, how you doing?' This is a people-oriented service, and you have to be customer friendly. People forget their car keys, wallets, phones, laptop computers—we give it to 'em. Ladies on the last run at night, they say, 'Oh, jeez, I left my car keys at work.' I give them a ride. I can't let a lady walk a mile and a half at 11:00 at night. Every Thanksgiving, New Year's, Christmas, Easter, I go around and shake everybody's hand, say, 'Hello, thanks for riding with us. I know you have a choice. . . .'"

The more time one spends with Naruszewicz, the clearer it becomes that social interaction is the part of his job that he relishes. He waves to familiar passengers from the wheelhouse, invites favorites up for gentle teasing ("Your face is awfully familiar. Didn't I see you on *America's Most Wanted?*"), and even jokes into the intercom ("We'll be arriving in Atlantic City in just a moment. Please

have your money ready."). Crew members banter amiably with Naruszewicz and offer him a series of disrespectful one-liners—the mark of real respect. That anyone should feature him in a book is a subject of great amusement to them. "Don't forget to powder his bald spot," says Ed. One of the deckhands cracks up.

Naruszewicz and the other crew members work three consecutive twelve-hour shifts, preferring that schedule to one spread over a longer period of time. They all take other jobs during the rest of the week. If he's not on the links in Long Island or fixing up his house for the wife ("Don't touch the plumbing," she has warned him), Naruszewicz works on *The Captain Log,* a fuel barge that services ships in the harbor, including the Circle Line fleet. He also likes to volunteer as a deckhand on the historical fireboat *John J. Harvey.* The latter job appeals to his naturally sociable side and allows him to show off his remarkable knowledge of the dense urban shorelines around him.

> *It's the romance of the waterfront that really attracts Naruszewicz—its history, its decaying structures—rather than any particular love for the water itself.*

Even when Naruszewicz is in action on *Harvey,* it's clear that it's the romance of the waterfront that really attracts him—its history, its decaying structures—rather than any particular physical love for the water itself. "Are you crazy?" he responds when asked if he ever goes boating or yachting.

As *The Bravest* slowly backs out of the 34th Street Pier, loaded with its cargo of solemn-looking men and women wielding briefcases and laptops, a line of other ferries is waiting to get in. The scene is reminiscent of that at airports when planes stack up before coming in to land. The hum of the engine and the sterile, odorless atmosphere of the wheelhouse only add to the aeronau-

tical impression. But as the sky darkens and *The Bravest* heads south toward the mouth of the harbor, this banality is forgotten and the nocturnal beauty of the city takes over. Manhattan becomes a gleaming wall of soft white lights to the right, and the maddening noise of the FDR, so overwhelming close up, gives way to a series of delicate red taillights floating past. Three bridges—the Williamsburg, Manhattan, and Brooklyn—suddenly line up behind each other, their spans a string of pointillist sodium dots. As *The Bravest* passes underneath each one, the dark gray waters turn into sparkling carpets of silver and gold

Manhattan's shores fade to those of Brooklyn and New Jersey, and then the ferry is in the wide open, with the sweep of the Verrazano-Narrows Bridge ahead. Naruszewicz gradually turns up the throttle until the boat is hurtling over the waves at thirty-two knots an hour, the waves vanishing beneath like clouds. For a while there is silence, broken only by the radio's sporadic crackle of maritime advisories, but suddenly a short burst of dirty laughter comes through. "Someone's been out on the water too long," says Naruszewicz with a sigh. "Don't worry. We'll all be home soon."

■　■　■　■

In 2003, about a year after this interview with Naruszewicz, New York Fast Ferry declared bankruptcy; both The Finest *and* The Bravest *were purchased by another ferry company, New York Waterways. Subsequently, Naruszewicz began captaining the maritime fuel supply vessel* The Captain Log *fulltime.*

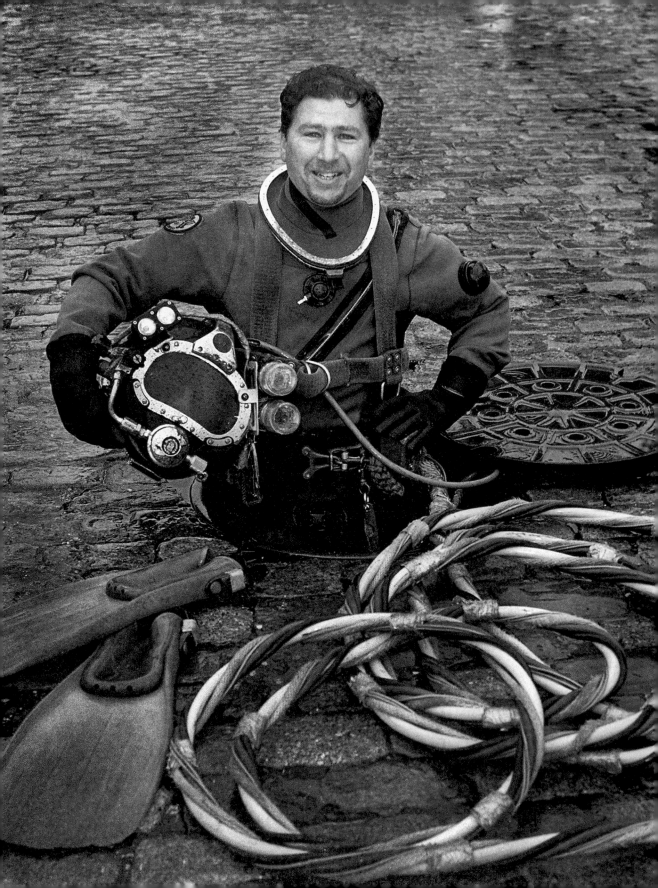

ADAM BROWN

Scuba Diver, Waterfront Activist

Very few people have seen the city from the perspective Adam Brown has. As a commercial diver he has virtually circumnavigated Manhattan underwater, silently inspecting the endless rows of pilings and bulkheads that line its edges, probing the mysterious channels that meander deep into its interior under the streets, popping down its manholes and sewers and sliding into the murky depths of its canals and creeks. He has helped carefully lower into place and bolt and weld together endless sections of the city's great underwater infrastructure—its bridges, caissons, ducts, and blades—and performed "pipeline penetrations," squeezing himself 1,000 feet or more into the inky blackness of a pipe sometimes no wider than his shoulders to check for wear and tear. His is the amphibian's-eye view of New York, a secret watery world that, like its counterpart above, contains a bizarre splendor once one's eyes are opened to it.

"You find beauty in a way that you don't expect," he says. "I remember one experience when I was diving under the FDR. It was early in the morning, and the sun was streaming down so the piles were like tree trunks and the sun was filtering through a forest—that kind of look. And suddenly I saw in between the piles and beams of light all these *eels,* just floating in midwater; their heads were up and the rest of their bodies just trailing off. There were dozens of them. I'd never seen anything like that before, and I just said, 'Stop!' It was an amazing sight. Every so often I'll see something like that, this one moment of beauty."

It's a dangerous world as well as a beautiful one. A simple kink in one's air pipe can prove fatal, and operating a soundless hydraulic chainsaw inches from one's face while being buffeted by currents of five knots or more is not for the

fainthearted. Brown considers himself a meticulously careful diver and preps extensively before every dive. "There's old divers and there's bold divers," he says, "but there's no old, bold divers. Guys that get cocky lose fingers and get dead." Even with this cautious attitude, Brown has had some near misses. Once, he was inspecting a power plant's intake when the blades suddenly started up, and he narrowly avoided being sucked in. "Another two seconds and I would have been diver tartar," he laughs. There's also an enormous amount of pressure exerted by the construction crews who wait for him above, usually with thousands of dollars per hour riding on the clock. "You're considered either super-

Brown has an amphibian's-eye view of New York, a secret watery world that contains a bizarre splendor once one's eyes are opened to it.

human or subhuman because you're expected to do underwater, in zero visibility, in freezing temperatures in heavy current, what it would take five or more men to do on the surface," Brown says. "And the contractor, the guy who's running the job, usually can't see what the diver's doing, so it's driving them mad. They think you're slacking off, you're sleeping, you're hanging out."

In fact, the last two can sometimes be part of a diver's job. If there's a holdup above, it's often not worth extracting the diver only to send him back down again, so Brown waits out the delay instead. "I've got plenty of air," he says, smiling. "I can either inflate my suit and float to the top of the pipe and stick there and take a nap, or, if I'm working in mud instead, I'll just scoogey down in the mud up to the point where I won't float away, and I'll sit there thinking about my life and rock back and forth with the surge, just like the seaweed."

Brown was born in New York City and grew up playing with his brother on the dilapidated piers and sheds along the Hudson River. His father was an artist; his mother worked for the Metropolitan Opera, a career Brown tried himself in his early years, combining it with his love of diving by alternating winters spent behind the scenes at the Met and summers spent underwater—"not that it usually worked out that way!" he says. It's a combination perhaps unique in New York history, and it explains a great deal about the "other" Adam Brown, the one who is an ardent and committed activist for New York City's waterfront and who uses the arts as a major means of achieving that end.

Since 1977 Brown has been president of the Working Waterfront Association, a group that advocates "for environmentally sound uses of New York Harbor compatible with traditional maritime activities," as his business card puts it. When Brown talks about this side of his life, his tone remains calm and amused, his compact body relaxed as before, but a certain passion—an ardor mixed with anger—becomes apparent in his choice of words, and a gleam appears behind his deceptively soft eyes.

"I think the problem is that the public process has gone wrong in a fundamental way," he says of the new waterfront parks that have sprung up around the city. "Everything had to be dumbed down." The result is a "very sterile, corporate feel" to a lot of the new development. Part of the challenge is getting people to look at the waterfront in a new way, or, as Brown emphasizes, "an *old* way." Unfortunately, the last forty years have done their damage: "People have been cut off for too long," he says. "They've forgotten what drew them to the water in the first place: the romance of the tugboats, the rusty fishing ships, the corrugated and variegated beauty—and not just these physical crenellations, but the personalities which you bumped into and the things you could do and see. I mean, that's why people go to these fishing villages that are grubby and smell like fish traps, and they stand there in their lime-green sportcoats eating chowder, thinking, '*Hmm,* I could have shipped out. . . .'" He laughs. "Better than being stuck in some office."

Brown realized that to make people think differently about what they

really want from the waterfront, he had to act indirectly; people could not be bludgeoned, but perhaps they could be lured into his way of thinking, and the arts seemed like a good way to do it. The Working Waterfront Association began holding waterfront festivals, bringing people down to the water and "giving them all kinds of experiences related to the water, whether it was a boat ride or dance upon the pier." One of the association's more recent ideas is the Tugboat Film & Video series, which sponsors young artists to create short works about the waterfront; these films are then shown on a working tugboat berthed at various points around the city. "It's a little subversive," Brown admits. "But if you get people to say, 'We want this waterfront designed so you can have a tugboat here,' then just on that very basis you've designed it for almost every general maritime use that we could hope for in a public area, keeping that public area open emotionally and physically. You don't necessarily have to do it, and not all the time, but it makes the argument without us ever having to say it. The public makes the argument for us."

On the whole, Brown is not optimistic about the working waterfront's short-term future, but there are signs that his vision is beginning to bear fruit. Certain structural changes to the new parks have been introduced as a result of his input, including the increased use of fendering along piers; moreover, an ambitious plan for a giant swimming area off Governors Island, reachable by public ferry, has cleared the initial political hurdles in Albany. But perhaps what most sustains Brown is that, in the end, he sees his ideas as being consistent with the essential nature of the city he loves. "New York is about transiting through communities," he says. "It's about having people from other places come into your community passing through. That's what made this city, and that's what Working Waterfront is about."

■　■　■　■

In 2004 Adam Brown left the Working Waterfront Association to form Silver Screen Marine, a company that offers a full range of services to film companies shooting in or on the water. The company's credits include the TV series Third Watch *and the Universal Studios film* Miami Vice.

OLGA BLOOM

Director, Barge Music

Olga Bloom is a woman with a mission; this much is evident the first moment you meet her. There's a complete scouring away of pretense, a determination to get to the essence of things, that would be daunting were it not also accompanied by her twinkle-eyed good humor and earthiness. Talking to her is like listening to your inner self—the good, true self whose voice is normally drowned out by the pieties and conventions of everyday life. It's both a bracing experience and a slightly shame-making one in its reminder of how most of us fail to live in the flame of the moment, as this remarkable octogenarian does.

Since 1977 Bloom has run Barge Music, a floating concert hall for chamber music in a converted coffee barge off Brooklyn's Fulton Landing in the East River. Four days a week, fifty-two weeks a year, she provides a venue for performers of all ages to realize this most challenging and intimate form of musical expression. The older musicians are usually veterans of major symphony orchestras here or abroad; the younger—who are astonishingly young, many in their early twenties and some even in their teens—are emerging artists who have already proved themselves in some of the world's toughest competitions and arenas. Barge Music may be small, but there's nothing small about its ambitions or the quality of the talent it showcases.

"Basically, I think I exist to prove that this can be done—that this one small, but of the *highest* quality, venture can exist and be influential," says Bloom. The young musicians seem to be her greatest motivation. "The time spent in the life of a musician between emerging from school and settling for the way you are going to survive is very short," she says. "I want to give those— and they are not many—who have gone through the discipline from the cradle

*Barge Music
may be small,
but there's
nothing small
about its
ambitions or the
quality of the
talent it
showcases.*

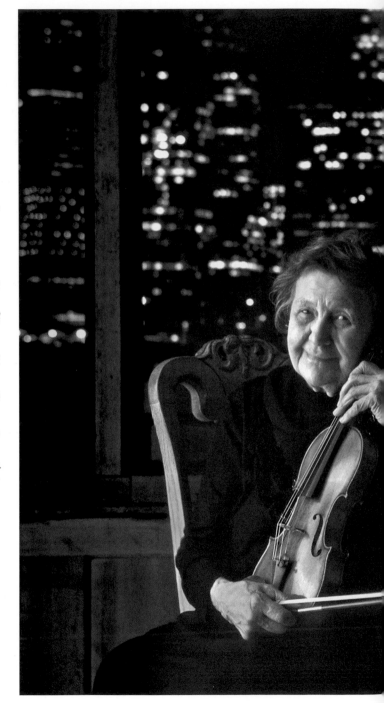

some hope that they can go out into the world and *have their own fate in their hands,* to be captain of your ship." She laughs at her own high drama. "Banal, but profoundly true."

Bloom, who was born in Boston and has lived near the water all her life ("It's part of my habitat and requirement," she says), was a fifty-seven-year-old professional musician, bored and a little disgusted by the professional scene, when she first took up the idea of Barge Music. "I played anything," she says, "*anything*—ballet, theater, recordings, symphonies." But it was a sense of almost existential dread that really drove her to a new career. "I was psychologically rather desperate, and morally in need to find out whether or not I was a token—what? liberal? I wanted to *live* the truth of my beliefs. That seemed to me important. It was the start of a great freedom—totally precarious, but that's a necessary ingredient, I guess."

When Bloom started Barge Music, the Brooklyn waterfront was far from the relatively genteel place it is now, and she was nervous about how the people who worked there might perceive her and her bizarre plan. "I knew I represented gentrification, and I anticipated a degree of hostility, even if it was simple withdrawal or reserve," she says. "On the contrary, when I arrived they just poured over the side to be helpful."

The first two barges Bloom purchased turned out to be completely unsuitable for her musical needs. One of them was an old wooden vessel that had been lying on a sand bed for years. "I realized it was a total disaster as soon as I spoke because you couldn't hear someone else talk 4 feet away," she says. "The planks were too thick, the wood was massive, and it just sponged up the whole sound." Finally, locals put her in touch with the Witte Marine Equipment Company, the famous maritime salvage yard on Staten Island. After much poking around there, Bloom found her current barge. But there was still a major problem to overcome: Because it was a steel barge, the vessel "over-resonated like a drum," she says. Something had to be done to make it suitable for the subtle demands of chamber music.

Undeterred, Bloom began an eighteen-month process of carting back old cherry wood panels she also found at Witte Marine, her old Volkswagen so laden down that the tires were almost flat. "I was guided by the principles of the violin," she says of using the cherry to line the inside of the barge. "It's part of the art of violin-making, or any stringed instrument, that the wood has to be able to vibrate and the air within the confines also." The resulting interior, beautifully covered in warm brown paneling, allows sound to travel from one end of the room to the other with crystal-clear precision.

For someone who describes herself as "never too socially driven," Bloom has a surprisingly powerful sense of her role in the community. An important part of her mission is to rejuvenate the frazzled and often alienated denizens of the urban environment in which she exists. "I've lived in the city for so many years," she says. "And I know that everybody who lives in the city tries to find some nature to establish a serenity of self

"I thought this would be the ideal amalgam: You have a body of water, you have the sky, you have the occasional bird fly by, and you have music."

again. I thought this would be the ideal amalgam, an integration of us and nature: You have a body of water, you have the sky, you have the occasional bird fly by, and you have music." The fact that her mission persists year-round, rather than on the more typical seasonal schedule of most artistic institutions, is also a source of pride to her.

With the great harp strings of the Brooklyn Bridge visible through her windows and Manhattan twinkling behind her, it's tempting to assume that Bloom has an easy life, unfettered by the usual stresses and strains of city existence.

23

Bloom soon puts one straight on that. The mundane and the tiresome reach into her life, too: There are egos to stroke, board members to face, sponsors to woo—the constant mating dance no endeavor such as hers can afford to ignore. And then there are such prosaic matters as sprinkler systems, sewage holding tanks, and power lines. "Oh, my dear, over the years I have become utterly under the reign of bureaucracy," she says.

A more recent problem has been the increased wake from new ferryboats, which Bloom says has dislodged paneling on the walls, broken her gangplank, and sheered her mooring cleats several times. She gets momentarily angry when cataloging these disasters, then suddenly laughs at herself: No one forced her into this precarious existence, after all. "I like the motion of the barge," she affirms. "Maybe it's just my freaky aesthetic. I think it's very good for people to be sitting serenely and suddenly to be jolted somewhat. I think that's *reality*. And I think that's where beauty lies. If there isn't an underlying terror,"—she lowers her voice conspiratorially—"if death is not an ingredient, it's not beauty; it's merely pretty, you know." She pauses for a moment and stares silently out of the window at the East River flowing ceaselessly past.

MIKE GALLAGHER

Shipyard Owner

Mike Gallagher was destined for the shipping business. His great-grandfather, Cornelius, emigrated from Ireland in 1860 and began in the sand and gravel business a few years later. Cornelius would sail a schooner out to Long Island, beach it at high tide, and then, when the tide went out, furiously load the schooner with sand by wheelbarrow before sailing back into New York Harbor. One of Cornelius's four sons compounded the family's success by marrying the daughter of their main competitor. This union produced a son—Gallagher's father—who became the third generation to join the family business, and in 1958 a young Mike seamlessly became the fourth. A series of solemn black-and-white portraits stares down from his office in Red Hook, Brooklyn, 130 years of family history on the walls.

Gallagher recalls his childhood: "I remember as a kid, you'd cross the Hudson River and come 'round the Battery. You'd come across fifty or sixty commercial vessels en route. You'd have the ferryboats crossing, the car floats going across with the rail cars, you had stick lighters, you had stone barges coming down from upstate New York with traprock, oil barges going up . . ." As he talks his tough, weathered face, etched by years in the outdoors, becomes animated, and an easy, schoolboyish grin slides out. A young man who takes a sheer physical delight in the water and all its activities sits just beneath the surface of the responsible businessman with his chinos, loafers, and beeper.

The magnificent graving dock at the center of New York Shipyards, Gallagher's business, is one of the oldest in New York City and one of only a handful still in operation in the city. Built in 1850 out of the ballast from old sailing ships that used to make runs to Europe, it descends, a vast ziggurat in reverse, 40 feet

The magnificent graving dock descends, a vast ziggurat in reverse, 40 feet into the ground—so deep that it taps into the water table beneath.

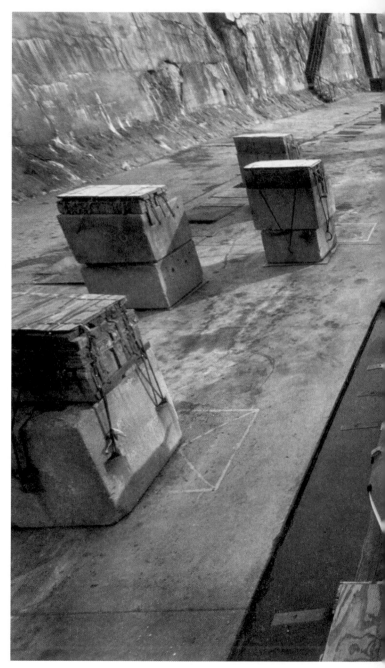

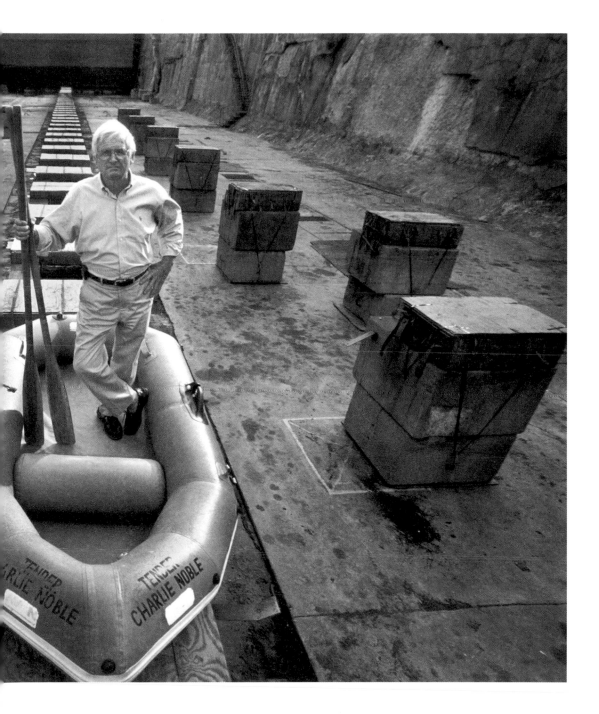

into the ground—so deep that it taps into the water table beneath, which gurgles up pleasantly near the rickety iron staircase at the bottom. Placed along its center are a series of concrete blocks capped with wood; ships that enter the dock rest on these blocks once the water has been pumped out. Each block weighs three tons, but within the massive confines of the dock, they seem more like a child's Lego set scattered casually about.

A 20,000-ton steel-hulled tanker sits jacked up on its blocks, reminiscent of a toy stranded in a bathtub. Gallagher leads the way underneath, his head almost scraping the rusty hull flecked with barnacles above. It seems impossible that the dry dock became available to New York Shipyards in 1985 because the previous owners feared it was too small for the upcoming generation of tankers. "Oh, yeah," says Gallagher matter-of-factly, "they're on the drawing board; they will happen, make no mistake about it. You're talking 12,000 to 16,000 containers, 1,000 feet long, 160 feet wide, 50 feet draughts." He reaches up and delicately picks at something on the ship's underside, as though pulling lint from a sweater.

This issue is of more than personal significance for Gallagher. For more than a quarter century, as a private businessman and then as head of the New York Dry Dock Association, he has campaigned vociferously for the need to upgrade the waterfront to prepare it for the future. "If they don't develop this Brooklyn waterfront, there won't be any port. That's my opinion," he says. Not surprisingly, the recent gentrification of much of New York's waterfront disturbs him greatly; it is "a noose around the city rather than a green belt" in his estimation. "Just to turn it into parks is absurd. The waterfront doesn't reproduce itself, and we're going to need every square inch of it, or the port's just going to get stagnant."

Ironically, a considerable part of Gallagher's income is now derived from those who see the waterfront, if not as a recreational facility exactly, then certainly as an aesthetic resource far removed from any sense of its functionality. "Film directors love us," he admits with a shrug. "We do shoots all the time." In fact, Spike Lee filmed parts of *25th Hour* in one of the vast unused machine shops, and opera singer Renée Fleming and rapper Ice T, unlikely bedfellows, have both found the area's aura of fashionable decay irresistible for their music

videos. The paradox is not lost on Gallagher, who flips with a mixture of pride and contempt through a recent copy of *Vogue* in which scantily clad models are arrayed around his premises. "It pays the bills, I guess," he says.

One wonders why he does it—why he stays in the business rather than retire to a life of sailing on his yacht, *Charlie Noble* (named after an old partner of his father), which is moored nearby. Why not just pack his pedigree Doberman and girlfriend Nancy—both of whom have great sea legs, he says—and simply head off on an endless around-the-world cruise? It isn't as if he still has something to pass on to his children. His eldest son, Timmy, once groomed to be the fifth generation of Gallaghers to helm the business, opted some years ago for the relative security of Wall Street. "I tell you what," says Gallagher. "He's doing better than his old man."

The answer to these questions comes on a day

"The waterfront doesn't reproduce itself, and we're going to need every square inch of it, or the port's just going to get stagnant."

when the 27,000-ton maritime cadet training vessel *Empire State IV,* which belongs to the State University of New York's Maritime College in the Bronx, is due to arrive in the graving dock for an overhaul. Men in filthy overalls, their arms bulging with muscles and tattoos, their speech a polyglot of Greek, Russian, and deepest Brooklynese, position themselves along the edge of the dock. Standing calmly amid them, dressed as though ready for a round of golf, is Gallagher, their CEO.

His eyes are sharply focused on the great white bulk of the ship as she inches forward, nudged gently by three tugs that surround her like anxious relatives. The wooden bung that seals the dry dock has been pumped free of water and floated clear, allowing in a flood of eleven million gallons of gray-green water that glistens brilliantly in the sunlight. *Empire State* makes an agonizingly

slow ninety-degree turn and begins to nose into the dock. At the front a winch starts up and begins to pull her forward, inch by inch. The men on board throw ropes over the side; they land on the dock with a thud. "Tie 'em up!" shouts Gallagher suddenly. "Hurry! Come on!" His crew swiftly picks up the ropes and ties them around a series of giant bollards.

Once *Empire State* is 90 percent in position, Gallagher jumps onto a tiny boat moored alongside called *John Noble* (another former partner) and starts her up. There is a guttural roar as her engine comes to life; black diesel fumes belch out from below. "She's got 350 horsepower," he says. "My father built her." Gallagher spins her around like a dodgem and heads out behind the stern of *Empire State,* which rises above him like a sheer cliff. Then he cuts *John Noble*'s motor, angles the boat's prow, and gently pushes it up against the monstrous orange rudder of *Empire State.* The engine roars again, and the waters churn black and white. It seems unlikely that this David-and-Goliath act will work, but *Empire State* is moving fractionally forward, Gallagher insists.

All the while he keeps the engine gunned and his eyes peeled on the men holding the ropes. Finally, one of the men shouts something to him, and he cuts the furiously revving motor and pulls *John Noble* away in a swift arc. *Empire State* is now lying exactly where he wants her, a passive whale, directly above the concrete blocks that will soon take her weight. In two hours' time all eleven million gallons of water will have been pumped out, and an army of men with welding tools and paint brushes will swarm around her hull. "It's time for a drink," says Gallagher, satisfied, and gracefully spins *John Noble* back to her berth. He may be the last generation of Gallaghers in the business, but nothing can take the pleasure of this life away from him just yet.

■ ■ ■ ■

In June 2005 the Swedish furniture company IKEA announced that it had purchased the New York Shipyards site for more than $30 million from Gallagher and his fellow codirectors in order to build a waterfront superstore. The shipyard's buildings and workshops have since been razed, though a spirited fight between IKEA and various activists over the future of the graving dock, which is scheduled to be filled in for parking space, is ongoing.

PHILIP FRABOSILO

Urban Angler

Philip Frabosilo's wife, Judy, has no doubts about the order of her husband's passions in life: "First Jesus, then his mother, then fish, then me," she says. Frabosilo's roly-poly face looks rueful for a moment, and he half turns around from the front seat of the taxicab he is driving at excruciatingly slow speed down the West Side Highway. "No, that's not true, love," he says.

"*Philip!* Keep your eyes on the road, Philip!" Judy shouts. Frabosilo smiles and turns obediently to face the front. "Thirty-one years, and I still survived all the insults, praise the Lord," he laughs. Regardless of whether the order is correct, Judy's comment neatly sums up the different aspects of her husband's life. A taxi driver by trade, Frabosilo is also a roving Christian minister and one of the most successful fishermen on the East River, claiming to have caught an astonishing 15,000 fish in the last ten years.

"I was always into fishing. My whole life, fish, fish, fish," he says in his powerful Brooklyn accent. "My fishing mania started when I was about nine. My mother began to take me to the piers. Canarsie Pier was the big pier I went to." It was there that he met the captain of a fishing boat, Captain Tommy, who invited young Frabosilo out for a ride, assuring his mother that he would "look after him like my own son." For the next five years, Frabosilo and Captain Tommy were inseparable. "When he sold that boat, it broke my heart. I knew *everything* about fishing as a little kid," Frabosilo says.

When Frabosilo grew up he discovered that being a cabdriver, with its built-in flexibility, was the ideal occupation for someone as fish-mad as himself. Every day, from May until about the middle of December (or later if the weather permits), he parks his cab somewhere near the East River, takes out

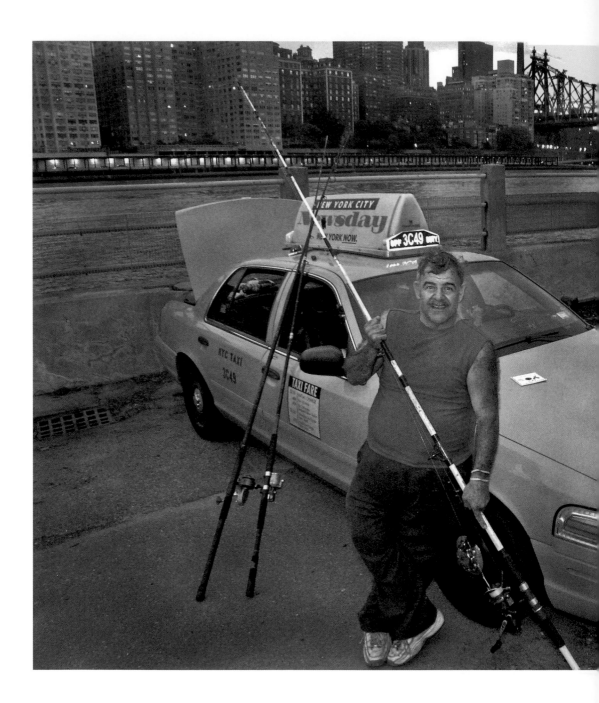

"My whole life underwent a metamorphosis. I would preach in the night, fish in the morning, preach at night."

one of the five rods that fill the trunk ("This is a limited service vehicle," he admits), and hops down for a couple of hours of blissful fulfillment.

Frabosilo's cab, dubbed "Rolling for Jesus," is one of the minor glories of New York, less a means of transport than a mobile shrine to his passions. Every square inch of the interior is taken up with photographs and objects, creating the sensation for a passenger of squeezing into a Joseph Cornell box. Naturally, snapshots of fish Frabosilo has caught—a fifteen-pound striper he snagged under the Brooklyn Bridge, a seventeen-pound bass he snared off Vernon Boulevard—adorn the walls. And at Frabosilo's side a well-thumbed packet of glossy 8x10 photos of his "monsters" awaits the fish-friendly passenger. Attached to the back of the headrests, for the edification of customers, are biblical quotations printed in large letters and laminated in plastic. (Psalms 16:1—"Keep me safe, O God, for in you I take my refuge"—is one posting, though Frabosilo changes them regularly.) There are also Bibles for the offering on the backseat.

Adding to the art-installation effect are the numerous Disney figurines that Frabosilo has adhered to his dashboard for his younger riders, afraid that they "weren't being addressed" in the car. He also keeps a large plastic bag of stuffed toys under the front seat. "I'm like Santa Cab," he says.

When Frabosilo finds a fruitful pocket of water, he will return to it for days. Last year he "milked" a spot under one of the Queens-side columns of the 59th Street Bridge for three weeks and caught dozens of fish, including a fifty-two-pounder. The stretch east of the FDR between 23rd and 30th Streets, alongside the private Waterside residential complex, is a regular haunt, though police move Frabosilo on whenever they catch him there. "Last year I hit almost thirteen fish in one week there, and two of 'em were in the twenty-five-pound class. Classics, my goodness." (This mild epithet is typical of Frabosilo, who punctures his sentences with "Amen" and "Praise be" just where the vigor of his sentences leads one to expect something stronger.) Frabosilo releases almost all of his catch, though he keeps a percentage of the stripers for home consumption, expertly slicing them into fillets or steaks. Sometimes, if people ask, he'll give the fish away to fellow anglers or to the homeless. Once, he went

so far as to give one to a passenger, cramming it into her suitcase, from which its tail stuck out.

For such an avid angler, Frabosilo has a rough-and-ready approach to equipment. Although he owns some fairly high-end rods, he's not above using old spark plugs as sinkers, and he eschews fancy bait from angling stores, preferring to freeze bait that he buys in the Rockaways. Part of this makeshift approach comes simply from watching his fellow urban anglers, many of whom make use of whatever is at hand. "There's a Puerto Rican guy," Frabosilo says. "He fishes with a *paint can*. He goes like this—*wssshhhh!*—and he can cast further than me! It's unbelievable."

It's people like that, in fact, whom Frabosilo credits with his "comeback" as a fisherman after a break of almost twelve years. After the double blow of his father's death and the sinking of his boat, he felt himself "going down, down" and decided that the Lord's hand must be in it, urging him to concentrate on his ministry. "And then I met this Puerto Rican on Roosevelt Island," Frabosilo recalls, his voice brightening at the memory. "I said, 'What do you fish here for?' And he goes, 'Are you kiddin' me, man? I catch 'em.' And right when he said that, a bluefish hits his rod—they *jump* in the East River; they're not like when you get 'em offshore—and I was stunned. And he said, 'Why don't you fish with me, man?' So I did—I began to fish with him, and my whole life underwent a metamorphosis. I would preach in the night, fish in the morning, preach at night. And then I learned the tides of the river, and in just two or three years, I became one of the top river fishermen." A proud smile creases his face.

Not surprisingly, Frabosilo can't resist using the odd fishing parable in the sermons he delivers at shelters and churches around the city ("I mean, the Disciples were all fishermen. It must be a pretty godly trade."). When pressed about his ministry, he shrugs. "The ministry is basically wild and woolly," he says. "I'm a mixture of everything. I love Catholics, but I don't love their ideology. I love Protestants, but I don't have a great respect for their '-ists' and '-isms.' I try to encourage people to begin a walk with the Lord on a daily basis. That's the kind of ministry I am."

Such a person does not go unnoticed in a city like New York, which loves to celebrate its home-minted "characters," and Frabosilo is no stranger to a limelight of sorts. A documentary about his ministry, *Rolling for Jesus,* was recently screened at the Brooklyn Film Festival, and he was the star—it's the only suitable word—of a 2003 documentary on the fishermen of New York City by author and filmmaker Robert Maass. Entitled *Gotham Fish Tales,* the film features an ebullient Frabosilo, who holds forth on the best ways and places to catch fish, clowns for the camera, and declares that he doesn't "lead a sedimentary life." At a recent screening of *Gotham Fish Tales* by the banks of the Hudson, Frabosilo and his wife arrived like a Hollywood power couple, except that they pulled up in their taxi instead of a limo.

Judy, who is the manager of a medical office and prefers quilting and antiquing to hauling fish out of the water as a hobby, seems to have long ago accepted her husband's infatuation and to have made allowances for it in their relationship. Early on, when they were engaged, she would go fishing with Frabosilo (they made several trips to Harlem and to Long Island); she even reluctantly went to Miami for their honeymoon because her new husband wanted to go surf casting (he deserted her on the first night, returning with a three-pound striper hours later). But since then she has put her foot down. "Now *I* make the rules about fishing," she says. "You see, I don't wanna be on a boat unless it's the *Queen Mary.*"

Frabosilo laughs loudly. "Now, if you look for one of our photo albums at home—this is really funny," he says, "—you see Judy in a rowboat, Judy at Shinecock, Judy at the surf, Judy here, Judy there . . . and then all of a sudden you don't see Judy like that anymore. You say, 'What happened, Philip, you got divorced?' I say, 'No, we got *married.*' " The two of them convulse. "It's really true," says Judy, wiping her eyes. "I hooked him, and that was all I needed." Still laughing, Frabosilo waves another cabdriver on at the entrance to the Brooklyn Bridge, then heads out slowly above the gray waters of the East River far below.

TEDDY JEFFERSON

Guerilla Swimmer

The wooden launching ramp for kayaks at Manhattan's Pier 63 slaps gently up and down on the Hudson's dark green waters. Straddling the middle of the ramp, legs apart for balance, is Teddy Jefferson, his slim brown torso recalling the pre–World War II urchins who used the river as their playground. He scans the horizon cautiously, noting the gray Department of Environmental Protection tanker moving sluggishly along the Jersey shore in the distance and the zippier yellow dot of a Water Taxi in front of it. "I'd rather swim here than anywhere else in the world," he says for a second time in his distinct tone of voice, half dreamy, half measured. Then he turns and with a graceful flick dives in head-first, reappearing a moment later to slick back his long, dark hair.

It's a steamy eighty-five degrees on the last day of July; the city air is like soup. Objects seem blurred in the thick light, and even sounds are tamped down by the humidity. Only the Empire State Building, gleaming dryly in Manhattan's concrete core to our left, looks cool and unperturbed. Jefferson waves to his more uncertain companion, and suddenly, incredibly, I'm in, immersed in this least likely of all of New York's myriad environments—the waters that surround it. A tentative roll of water in the mouth reveals it to be warm and faintly brackish. "Nice, isn't it?" asks Jefferson. "About seventy degrees, I'd say."

Jefferson has been swimming in the harbor since 1996, everywhere from behind the Statue of Liberty to the Erie Basin in Red Hook, Brooklyn, but the Hudson River piers along Chelsea and the West Village are his favorite spots. With his friend and co-guerilla swimmer, Mark Heath, Jefferson founded Swim the Apple, a group dedicated to "swimming and the development of swimming facilities and structures in the waters of New York City," as their Web site puts it.

Jefferson has a faintly mystical vision of what Manhattan might be like—a place where people could embrace the rivers as part of their daily lives, much as Indians do the Ganges.

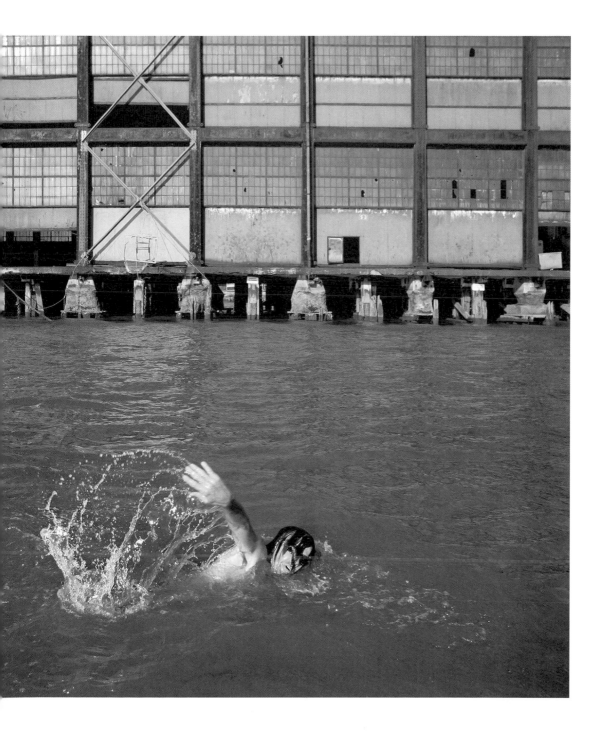

The group offers regular free swims around the city and advocates for swimmers' rights at endless community board and city planning meetings.

All of this activity suggests a character quite at odds with the quiet, thoughtful, and absolutely non-self-promoting Jefferson. He is the least bellicose of guerillas, the least agitated of agitators, as he himself is the first to admit. "I'm not an agitator. Because a real agitator would do things to—no pun intended—make a splash. You know, stir up trouble to focus on things. My impulse is actually more the opposite, because if I had my mug shot up in the Parks Police, everywhere I go they'd be saying, 'Watch out! That guy might jump.' And if you swim in conditions like that, it would be no fun at all." His movie-star-handsome face looks momentarily forlorn at the prospect.

In fact, the impression Jefferson first makes is more that of a fastidious European prince who has chosen to live incognito than of a modern-day New Yorker. He wears narrow-legged jeans with brown dress shoes, has delicate tapered fingers, and arrives on an old-fashioned bike that looks like something out of *Brideshead Revisited*. The European look is no coincidence: Jefferson was born in Paris and lived in Rome for nine years, where he still has "a complete parallel life, conducted in another language." He works for an Italian news service, editing and translating syndicated op-ed pieces for a number of daily newspapers, but spends his afternoons writing plays, a number of which have been performed "very off-Broadway," as he puts it. (His latest one is about a man who offers a free meal and a beer to anyone who will let him execute them afterwards.)

Jefferson is not, it turns out, a fan of the city he lives in, despite his love for its waterfront. "If I could, I would probably move back to Italy," he says. "I find this current phase in the city really a very ugly period. It's as if it's undergoing an invasion by a kind of class of people who do nothing but shop and hail cabs. The streets are completely denatured." His pronouncement on the nation as a whole is even harsher: "Of course, we're in the very last stages of our culture now, the one where we send our military out against everybody who disagrees with us." A faint smile plays across his lips. "It is, though, a good period for playwrights."

Jefferson wasn't an avid swimmer as a boy (he has always loathed swimming

pools, with their chlorine), but as he grew older and started traveling, he developed a romantic, almost anarchic, attachment to the industrial waters of the world's great cities. "If you can swim," he says, "then you can basically sleep anywhere you want. You don't need plumbing. You just buy bread and a piece of fish, and you're taken care of. If you go in the water, you can live much better." His is a faintly mystical vision of what Manhattan might be like—a place where people could embrace the rivers as part of their daily lives, much as Indians do the Ganges. One gets the impression that he would be delighted if New Yorkers started doing their bathing and laundry in the Hudson. Swimming, for him, seems more a communion than a hobby. "A river is a living body of water," he emphasizes. "The mix of salt and fresh gives some kind of energy to the water which is very—you just *sense* it."

Swimming in New York waters is not illegal, but it's not exactly legal either. Big organized swims, such as the annual event sponsored by the Manhattan Island Foundation, are held with the permission of the Coast Guard and the New York Police Department; Swim the Apple's more low-key events, and particularly Jefferson's solitary explorations, are frowned on by authority. As a result, he keeps a beady eye out for trouble. After twenty minutes or so of swimming around, during which time he ventures past the protective bulk of the old lightship *Frying Pan* and begins to feel the tug of the river's current, he heads back to the launching platform and pulls himself out as effortlessly as a seal. He's just in time for the berthing of the historic *John J. Harvey,* loaded with trippers after a voyage around the harbor. The crew's attention is elsewhere, but the trippers openly gawk at the sight of two men soaking wet in swimming trunks.

A few minutes later Jefferson returns to the relative seclusion of the north side of the pier and points out a hot-water shower, activated by pulling a string, that kayakers use. He is waiting for his wife, Ladane, who is Iranian, and their two young children, son Syavash and daughter Paranvh, to join him for another dip ("My Persian and the little rascals," he calls them.). With complete composure, and exuding an ineradicable urbanity, Jefferson settles down at one of the pier's small cafe tables, a shirt and pants thrown casually over his lean frame, only his slicked-back hair a clue to his recent guerilla adventures.

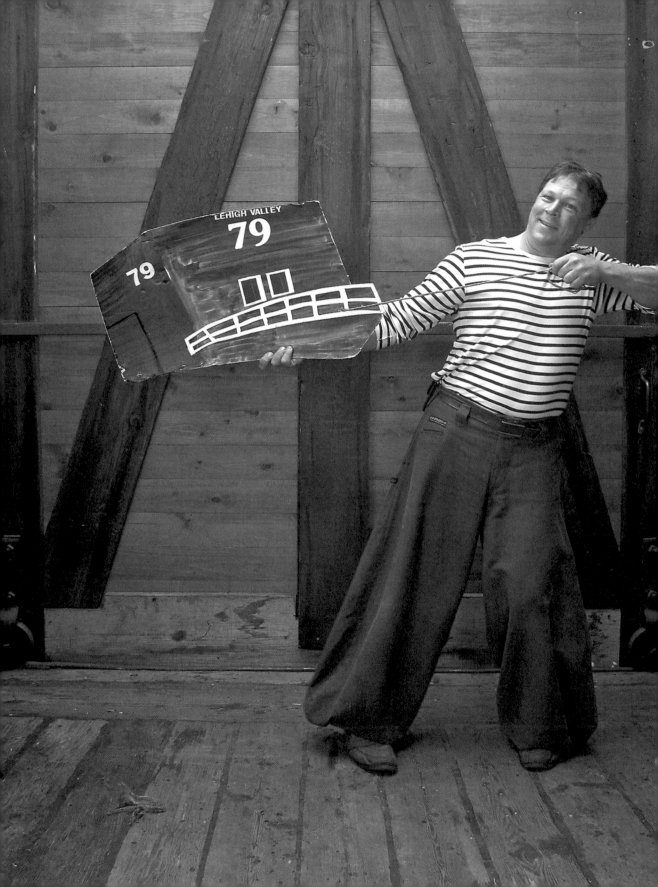

DAVID SHARPS

Waterfront Historian, Barge Owner

Follow Brooklyn's ragged shoreline southward, under the imperial spans of the Manhattan and Brooklyn Bridges and past the whitecaps of the Buttermilk Channel, where the current squeezes past Governors Island, and you arrive at the Erie Basin, a vast man-made harbor sticking out into the bay like a fishhook. Although its commercial heyday was long ago, it still exudes an air of nineteenth-century assurance, as do the other industrial anachronisms that surround it—the brooding silos of a grain terminal, the row of concrete monoliths that form Industry City farther south, lining Sunset Park's waterfront.

Alongside one of the piers that jut into the placid waters of the basin's interior, David Sharps has found a suitable home for the great passion of his life: his 1914 wooden lighterage barge, *Lehigh Valley #79*. Given her relative fragility, she is every bit as astonishing, perhaps more so, than the architectural relics nearby. Her name, supplied by her original owners, the Lehigh Valley Railroad Company, is suitably prosaic for a floating wooden slab that looks more like a stockade than a vessel. Her facade resembles a boardwalk; the smallest of punctures at either end suffice for windows. On this early summer morning, as the sunlight plays across her wide plank floors and the smell of brine wafts in from a sliding door, Sharps is teaching a visiting group of schoolchildren about his barge's venerable history and that of the harbor it once toiled in.

"How many of you have been in a traffic jam before?" he asks the faces staring up at him. There's laughter because their school bus was nearly an hour late due to traffic. "Well, that's how this harbor was with boats years ago," he says. Sharps goes on to explain *Lehigh Valley #79*'s role in a fleet that used to carry cargo across the river from one railway terminal to the other, and how

she used to be pushed by tugs. "How many of you know what 'obsolete' means?" he asks. There's silence. "*Ob-SUH-leet.* You know, like vinyl or cassettes. How many of you remember listening to music on cassettes?" The kids laugh again in recognition, their little bodies loosening up. He talks for fifteen minutes more about the Native Americans who once lived in the harbor and the white men who came afterward; then, with the intuition of a natural performer, Sharps the Teacher becomes Sharps the Entertainer.

"Okay, let me stop talking. I'm gonna see if my orchestra showed up." He darts over to a tape deck set up at the back. Loud circus music starts pumping out, and Sharps strips down to his T-shirt and grabs a bunch of juggling clubs.

Given her relative fragility, Lehigh Valley #79 is every bit as astonishing, perhaps more so, than the architectural relics nearby.

"I want you to pretend you're on a cruise ship," he says, and begins to throw the clubs in a dizzying arc above his head. Sometimes he pretends to have forgotten a club and then spins at the last moment, a look of comic woe etched on his face, catching it just before it falls. The kids love it, clapping and laughing along as Sharps's face glistens with the effort. When they file out happily into the sunshine for lunch, they're chattering excitedly, a fraction of their normal inner-city veneer removed and replaced with something approaching unguarded childishness.

Sharps has been giving such courses since 1994, when he became the self-appointed captain and curator of his Waterfront Museum. His journey to the position of teacher-clown-preservationist, tucked away in an obscure corner of New York's harbor, was an unlikely one. The son of a car dealer from Appalachia, Sharps began with more mundane ambitions, first attending busi-

ness school, where he played on the college golf team (he still keeps a bag of clubs on board), then working as a juggler at a hotel in Maryland before getting his big break as an onboard entertainer with the Carnival cruise ship line.

After leaving Carnival in the early 1980s, Sharps continued his maritime life by moving to Paris and living on a barge on the Seine for a year while he studied with the prestigious Jacques Le Coq International Theatre School. A grainy video from the period shows a fresh-faced Sharps and his partner pretending to be window cleaners on a platform. As the dullness of their task becomes unbearable, their imaginations take over, and they start to see themselves not as unromantic laborers but as shipwrecked mariners, waving their rags in the air and bailing out their sinking "raft."

Sharps subsequently found himself back in New York, and it was here that his video performance became a reality when he discovered *Lehigh Valley #79* half sunk in the Hudson River off Edgewater, New Jersey, near the George Washington Bridge. Sharps knew at once that he had to have her, especially when he discovered that she was the last of her kind. Against the advice of almost everyone, he spent two years pumping thousands of gallons of mud out of the barge, followed by another two years of making major repairs. His business school background proved useful at last as he negotiated the arcane rituals of grant-writing in order to raise money for the project—something he has since become remarkably adept at, receiving numerous substantial financial awards.

There is a ferocious quality to Sharps that lurks beneath his sunny entertaining skills and his high-pitched, soft Southern accent. You don't embark on the nautical equivalent of cleaning out the Aegean stables unless you are driven by a philosophy of sorts, and Sharps's philosophy, a form of social revolution in effect, becomes clear as he talks. One of his pet causes is to convince the city to issue permits to him and like-minded souls who want to restore landings in disrepair. As he discusses the situation, his voice rises in amazement at the indifference or outright hostility he has encountered. "I've seen permits denied because the property was '*beyond repair*,'" he protests. "I'm asking permission to fix it, and you're telling me it's beyond repair? I'm offering to *pay* for it, I'm offering

to *design* and fix it and *rebuild* it back to a state where it was at its glory, and you're telling me it's beyond repair?" He runs his hands through his hair, face flushed. "My boat you're sitting on was beyond repair—sitting on the bottom of the river and forgotten by even historians. And I'm a *clown!*"

For Sharps, the real reason for such refusals is a deeper, society-wide malaise that began with the destruction of the railroad system. "We've lost so much more than even our entire transportation system. We've had the wind taken out of our sails as a country," he explains. "We've changed the American way from hard work to people looking for ways to make money where they don't have to work. I mean, it's prevalent—oh, it goes with your dropped ceilings and your skinny two-by-fours. We don't overbuild. Things are broke; there's planned obsolescence." He pauses, looking for the exact words. "And this barge is the antithesis of that."

The water slaps lazily at the barge's hull, and for a moment it's possible to imagine that cars and roads and a whole century of automated "progress" never took place—and that *Lehigh Valley #79* is still in operation, crossing the Hudson every day, laden with cargo and full of purpose.

■　■　■　■

Lehigh Valley #79 has since found a new home in Red Hook, just north of the Erie Basin at Pier 44. In addition, in May 2006 Sharps obtained "attraction vessel" status for Lehigh from the U.S. Coast Guard, allowing her to travel under tugboat power around New York Harbor and its waterways.

MANNY PANGILINAN
AND JOSH HOCHMAN

Surfers

Manny Pangilinan is slim, goateed, and serious in a laid-back way. He's also something of a philosopher. "The water, whether it's surfing or, like, just picking for shells or riding a boat, the water does something to you—it turns you into a character like Jacques Cousteau, you know? There's something about it; even the breeze does something to you. And that's why I want to go back to my roots. I'm Filipino. I just want to be near the water, because I think the cells in my body are designed for that."

His companions, sitting in Williamsburg's Surf Bar in Brooklyn, with sand on the floor and surfboards hanging from the ceiling, laugh. "Manny's waxing poetic again," says his friend and fellow surfer Josh Hochman. "Watch out." But waxing poetic is something that surfing seems to bring out in people, and soon Hochman is in poetic vein, too. "How often do you get slammed and put down by a force of nature every day?" he asks. "It's humbling, and it helps make you more of a humble person—the effort it takes to get one small thing that has so much work to it."

At 7:45 that morning, with the temperature hovering around forty degrees and the sun trying unsuccessfully to break through a cover of black and pearl clouds, Pangilinan and Hochman had arrived at Beach 92nd Street in Hochman's old Subaru. They struggled into their black "4-mil" wetsuits and, after stretching briefly, jogged across the sand, surfboards under arm, and plunged into the freezing green waters of the Atlantic. About 30 yards out waves 4 or 5 feet tall, stirred up by Hurricane Wilma a thousand miles away in Florida, were rolling in and crashing in billows of white spume. A crowd of

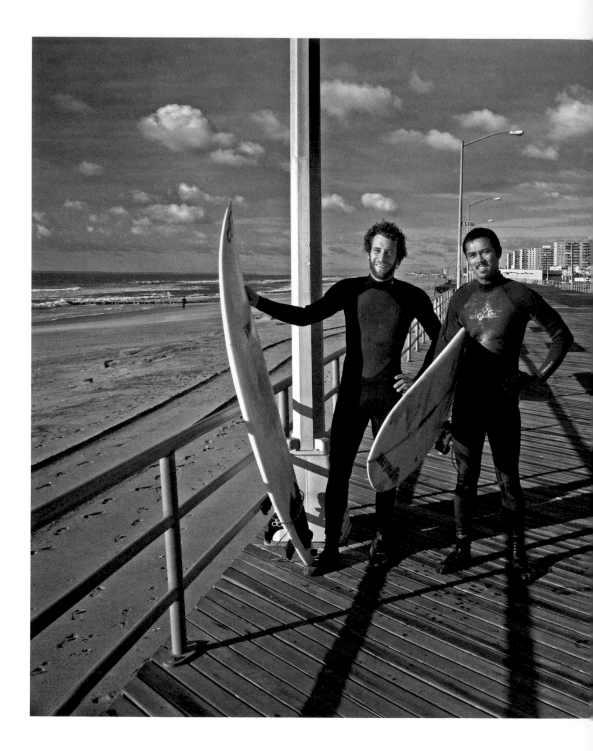

"How often do
you get
slammed and
put down by
a force of nature
every day? . . .
It helps make
you more
of a humble
person."

eight or so on the boardwalk watched casually, mostly dog walkers; one middle-aged woman shook her head at the folly of it all.

Pangilinan and Hochman spent some time paddling beyond the breakwater point and soon became indistinguishable from the half dozen other black-clad figures already out there. Occasionally, a figure would rise up, knees bent, arms outstretched, suddenly accelerated by the full force of the ocean, before vanishing. The more spectacular wipeouts were signaled by the flash of a surfboard, glinting like a giant fish, as it shot up into the sky. By 9:00 A.M. the waves had died down considerably, and Pangilinan and Hochman emerged, flushed of face and grinning uncontrollably. Both had caught several waves, though, as Hochman said breathlessly, "One would have been enough. It's all I need. I could have stopped right then and been happy."

Rockaway Beach, a 6-mile stretch of sand complete with its own boardwalk, is one of the best—many surfers would say *the* best—place to surf on the entire East Coast. (Montauk has its adherents, but Pangilinan and Hochman are not among them.) Compared to the other surfing meccas of the world—Hawaii, California, Costa Rica—Rockaway seems laughably lacking in natural beauty or sophistication. It is a determinedly blue-collar strip, backed by high-rise residential blocks in uncompromising shades of red and gray and, to the east, the termite-mound silhouettes of the Far Rockaway housing projects. It's even accessible by *subway*.

For the surfers who flock there, however (and for its loyal residents), Rockaway holds its own in every sense. Pangilinan recalls being in the water on many summer evenings and seeing whole schools of fish jumping out of the water "like shining silver dollars." His friend and avid surfer, Colin Ackers, who coached him into his first big wave, has seen waves glowing bright green with plankton at night and "sea smoke" rising off the surface, a process that occurs when the water temperature is warmer than the air and the ocean condenses in great clouds.

Pangilinan and Hochman—not to mention Ackers—are very different people, yet when they talk about surfing, it becomes clear how unifying the sport is, how much it creates a sense of fraternity. Part of this is due to "surfer talk," the

drawling, West Coast slang they all employ. It's fun to hear Hochman, a Jewish man from Cleveland, Ohio; Pangilinan, a Philippine American who grew up in the New York suburbs; and Ackers, New Jersey born and bred, drop such phrases as "gnarly waves," "getting shacked," "totally ripped," and even "surfer chicks," all without any sense of irony. But they seem unified in a deeper sense as well. Surfing changes the way you look at yourself and the way you look at the world. It's more than a pastime; it's a spiritual pursuit. "It's like experiencing Earth in another way," Pangilinan puts it. "You can't lie to the water, you can't lie to the waves. If you get out there, you've earned it. You've skillfully understood and respected the waves, and when you catch that wave, that's your wave; you've earned it, and you know what? Money can't buy that." Ackers agrees with this notion of natural harmony. "You can just smell

Surfing changes the way you look at yourself and the way you look at the world. It's more than a pastime; it's a spiritual pursuit.

waves sometimes; it's weird. I was in college 16 miles inland once, and I went, 'Oh, man, waves are up!' I called up the surf reports, and they're like, 'Yeah, it's perfect.' " His dark, liquid eyes light up in amusement.

People come to surfing by different routes, and they adopt different lifestyles to sustain it once the bug has bitten deep. For Pangilinan and Hochman, work is a means to support their passion rather than something necessarily rewarding in itself. Pangilinan, who has been surfing since 2000 but skateboarding seriously since 1979, when he was seven, is a freelance carpenter who has held various jobs, including stints in a museum woodshop (where he fabricated display cases and installed art) and in an advertising agency. The latter, a full-time job, was particularly taxing for him. "I was like, you know what? I'm not in New York City to keep my body alive and pay my rent. Fuck this, I'm

out of here." The freelance life allows him to surf pretty much when he wants and even affords him the opportunity to travel. A few winters ago he found his dream job: carpentry work in a million-dollar house in Kauai, a position he found online on craigslist. "Super-cool people. I had the master bedroom." Hochman, by contrast, works full time as a computer programmer in Soho. It "pays the bills," but he'd rather be freelance. As it is, protected by the fact that he has certain skills that are in demand, he often doesn't get to the office until 10:30 A.M., after a morning surfing at Rockaway. "I have nothing to lose," he says, "though I feel guilty sometimes and work a bit harder when I'm there to make up for it."

Hochman, who is a year younger than Pangilinan, came to surfing via the entreaties of his brother. When the brother moved from Miami Beach to New Jersey, Hochman started surfing with him every weekend. It was, he admits, a good way to put the stress of a failed marriage behind him. "It's one of the most therapeutic things you can do," Hochman says. Both he and Pangilinan were lucky to have a friendly mentor help them with their initial forays into surfing. Pangilinan says he will remain forever grateful to the far more experienced Ackers—who has been surfing for seventeen years—for helping him. "For Colin to hook Manny up like that, that's cool," says Hochman. "Not many people do that."

There is a supposed etiquette to surfing, in which people offer first-timers advice and try to keep out of each other's way; Hochman says he has been saved more than once by another surfer allowing him to grab on to his board when he was caught in a riptide and flailing badly. But a great deal of the time, especially if conditions are particularly good, surfers are out to maximize their pleasure at the expense of everyone else. "Some people just become monsters in the water," says Pangilinan. "They just try to catch every wave; they become really hard." Ackers laughingly recalls an incident a few years ago in Rockaway when "two dudes got into it in the water, and one guy actually paddled over to the other and head-butted him."

Surfing is dangerous enough without such behavior. The litany of accidents Pangilinan and Hochman casually recount is enough to make anyone reconsider it as a recreation. A week earlier, a surfer had broken his arm at Rockaway and two others had needed stitches after they were slammed down hard on the sand. Ackers has dislocated both his knee and his shoulder, and Hochman also wrenched his knee out in Costa Rica once; he had to knock it back in himself, screaming in pain. Numerous people have drowned, too, most notoriously in 2001, when three teenage girls were caught in a riptide off Rockaway Beach and dragged out to sea. And just that morning, Pangilinan had been caught in what he calls "the toilet bowl," a swirling rip current that kept him unable for some time to paddle in to land.

As a result of these dangers, authorities have long come down hard on surfers who surf outside of the brief summer hours when lifeguards are on duty at Rockaway. Police would periodically blitz them with tickets, and at 6:00 P.M., after the lifeguards left, Ackers says that the park rangers would come by in their 4x4s, ordering everyone out: "Get out of the water! You're gonna die!" A few months ago, Rockaway surfers won a major victory when the Parks Department and the city council agreed to designate Rockaway Beach between Beach 90th and 92nd Streets an official surfing area, meaning not only that surfers can use it with impunity but also that swimmers and other water users, who often create a dangerous mix, have to keep out.

Given the intense rewards that surfing offers its devotees, it seems unlikely that something as earthbound as rules and regulations could have stopped the activity anyway. As Pangilinan says, "The ocean is a serious thing. There's no rules to that type of area. When you come out of the water, you're in your own zone, and the people on land, they're in another zone. They're two totally different places." Hochman puts it even more succinctly: "Time is just extended out there."

GREG O'CONNELL

Waterfront Developer

Greg O'Connell is a big man. The cell phone that he holds delicately to his ear looks like a toy that might have come out of a cereal box. "Listen," he tells the caller, "we're gonna have a real sit-down with them soon, okay? But we need time to work out a proposal first. We're not gonna be rushed, and neither is the community board." The voice at the other end apparently acquiesces, because O'Connell clicks the phone firmly shut a few seconds later. It's the third time it has rung in as many minutes. Behind him, through one of the open window frames of the massive stone warehouse he is busy restoring, lies O'Connell's domain: the gray-green waterfront of Red Hook, Brooklyn, rimmed with its stubby piers and solid nineteenth-century industrial buildings. In the background, so pale and insubstantial in the hazy morning air as to appear almost an afterthought, stand the silent peaks of Manhattan.

O'Connell is that slick and untrustworthy creature known as a real estate developer, one who has systematically accrued so much property in this out-of-the-way neck of Brooklyn's waterfront that a few years back the *Times* dubbed him "The Baron of Red Hook." Except there are some differences: Most real estate developers don't wear blue overalls and working boots; they don't have a Queens accent you can cut with a knife, and they certainly don't drive twelve-year-old pickup trucks whose odometers have gone around the clock. Much more importantly to the people of Red Hook, most developers don't have a vision that allows nonprofits to stay free or at low rents, and most do not actively turn down the chance to create fancy market-rate condos in favor of leasing space to glassblowers, Key lime pie manufacturers, handbag designers,

and furniture makers. "The thing about Greg," one long-term tenant says, "is that he's really a closet liberal."

O'Connell's first brush with real estate came when he was enrolled in the State University of New York's Geneseo College, studying to be a teacher. His fellow fraternity members all had been complaining about high rents in the area, but it was O'Connell who came up with the idea of pooling their money and buying a house, and who turned this idea into a reality. "That was my first real estate deal," he says, "and believe me, if you can handle a bunch of eighty crazy college guys, you know after that it's just not so difficult."

> O'Connell is that slick creature known as a real estate developer—except that he wears overalls, drives a twelve-year-old truck, and is, according to some people, a closet liberal.

After college, following in his father's footsteps, O'Connell became a cop. With his imposing 6-foot-4 frame, he was placed in the newly formed Tactical Patrol Force, where he did "short posts"—saturating dangerous hotspots for a few weeks at a time. It was the late 1960s, and New York seemed caught in a paroxysm of violence. "I mean, crime was rampant then. Today's like nothing," he says, with just a touch of pride. "You had race riots in Harlem and Bedford-Stuyvesant. The Two-Oh—the West Side from Amsterdam to Columbus all the way over—it was like a bucket of blood up there. You could go down that street, take your gun out, fire two shots in the air, wouldn't make a difference. No one would care! It was like going for a country walk."

O'Connell runs his hands through his thick hair and laughs. Then, perhaps wishing to dispel any sense of impropriety, he adds carefully that throughout it all he bore in mind his father's dictum that "you always treat the poor unfortunate on the street and the judge on the stand the same way." The honest cop and the pragmatic businessman seem fused in O'Connell, a natural marriage of sensibilities rather than anything disingenuous, and it may be this quality as much as anything that is responsible for his success.

O'Connell freely admits that he never would have built up the social and psychological skills necessary for the tricky art of real estate negotiation without the diverse experience of being a cop, and later a narcotics detective. "Oh, it was a great education," he says, "no doubt about it." It was also, just as importantly, a crash course in real estate itself. With a good eye for deals, O'Connell quickly saw that great swaths of the city were up for grabs if one had a little money to spare. The Upper West Side might be a "bucket of blood," but with the newly minted concept of urban renewal in full swing, entire townhouses were to be had for a mere $15,000 deposit. O'Connell arrived too late to get in on this particular opportunity, but he did begin to buy real estate in Brooklyn. His first purchase was a house on Henry Street in Cobble Hill, which he bought in 1967 for $22,000, with $9,000 down. He moved on to Columbia Street and finally Red Hook, arriving in 1981, the year he retired as a police officer.

For those visiting it for the first time, Red Hook can seem a daunting and desolate place. Orphaned from the rest of Brooklyn by the Brooklyn-Queens Expressway, which gouges a deep trench through the city fabric, and far from the nearest subway, its spectacular waterfront of stone and brick Civil War–era buildings and the mangled steel remains of later, less robust, structures is guarded by a ring of small streets packed with auto-repair stores and parking lots. Their dismal frontage has until recently done a good job of dissuading further pursuit. Urban renewal very nearly finished off the waterfront altogether in the late 1960s and early '70s, when the city and the Port Authority between them bought every building they could get their hands on and promptly demolished it as part of a massive slum clearance project.

Today, the tentacles of gentrification are apparent—Red Hook is "hot" now, though far from being a supernova like DUMBO (Down Under the Manhattan Bridge Overpass) or Williamsburg. Bistros and boutiques stick their heads out bravely and a little uncertainly from the bodegas on Van Brunt Street, and there's a smattering of trendy bars, but the area still retains a distinctly feral nature, a place where serious commercial and manufacturing business is done. O'Connell is determined to ensure that continues.

"Does everything have to be sexy?" he asks. "You know what I mean? Somebody's gotta wake up. When 'high-end' folks move into these kinds of neighborhoods, you know what? It's a shame, because a lot of time the reason they move there is gonna disappear." *Work* will be this area's mainstay if O'Connell has anything to do with it— trucks and cars and ferries (he's already established a new landing pier for the New York Water Taxi system) and noise and life, the bustle of the city kept alive and not shut out. Men in suits will have their place, certainly (O'Connell is building some luxury condos amid his other developments), but there will still be plenty of men in overalls like himself.

Work will be this area's mainstay if O'Connell has anything to do with it— trucks and cars and ferries and noise and life, the bustle of the city kept alive.

O'Connell plans a Fairway supermarket on the ground floor of a massive warehouse he owns at the end of Van Brunt Street, which will bring much-needed jobs to the area. Three nonprofit groups will be housed in generous quarters above for free; one of them, Red Hook Rise, is involved in reaching out to the youth of the enormous Red Hook housing projects nearby. A sop to

a liberal's conscience? The idea crosses one's mind despite O'Connell's long track record of such altruism—it's hard to let go of that innate suspicion of developers, after all—but he is convincing: "I'm giving them 7,000 or 8,000 square feet. It's gonna be their home. They're not gonna pay rent, okay? Why? Because they have a positive effect on Red Hook, in the community, the people in the houses, you know? They've demonstrated to me that they have a commitment to Red Hook." His pugnacious sincerity makes one feel guilty for even entertaining suspicion.

O'Connell's phone rings again; with an apology he flips it open and leans against the wall to answer it. It's his secretary calling: Con Edison workers are outside one of his buildings and can't find their way in. "Guys, I gotta go," O'Connell sighs. "In this business, it never stops, y'know?"

■　　■　　■　　■

In May 2006 the Fairway supermarket chain opened a 52,000-square-foot store employing 200 people, many of them locals from the Red Hook housing projects, on the lower level of O'Connell's flagship building, the former Red Hook Stores warehouse on Van Brunt Street. Its upper floors provide live-work residences for artists and space for nonprofit groups, as a well as a number of private apartments.

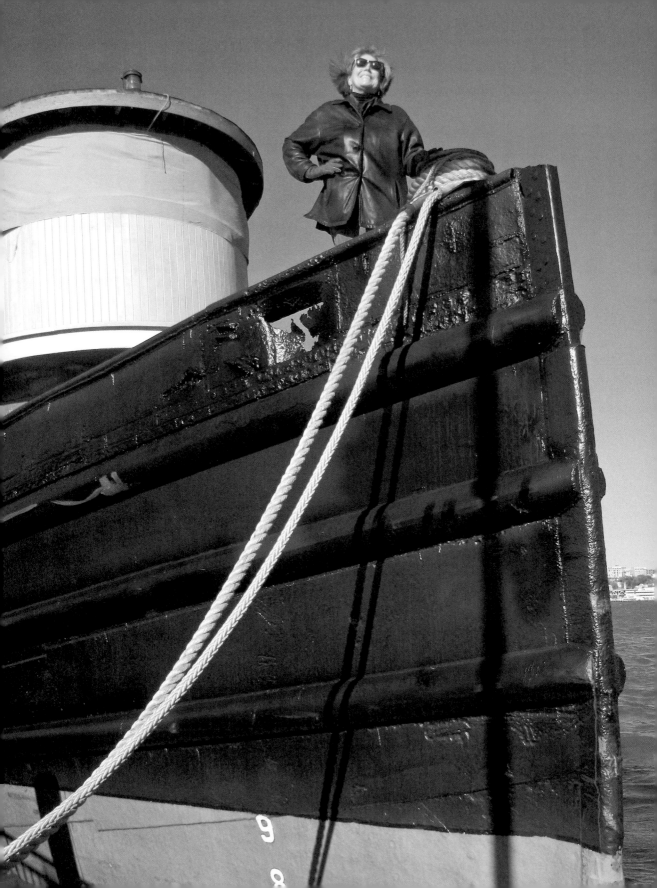

PAMELA HEPBURN

Tugboat Captain, Marine Preservationist

Walk through the entranceway to the Chelsea Piers Sports and Entertainment
Complex, with its brightly colored signs announcing golf, rock climbing, and
basketball, all in unimaginable amounts of square footage, and head to the end
of Pier 62. There, berthed in the Hudson's waters, is a battered burgundy hulk,
her wheelhouse boarded up and covered with a tarp, the name *Pegasus* scrawled
on her side. With her chunky, maternal lines, topped off with the usual tugboat's
flourish of old car tires at the bow, she seems like a quiet rebuke to the frenetic
commercialism that surrounds her and provides an especially ironic contrast to
the sharp white prows of the modern pleasure boats moored nearby.

 Pegasus's owner, Captain Pamela Hepburn—tall and handsome, in her
mid-fifties with steel-gray hair—is one of the only women ever to captain a
tugboat in New York City's harbor, and undoubtedly the only one to raise a
child on board. She obtained her pilot's license in 1985 and hauled cargo around
on other people's boats before purchasing the almost eighty-year-old *Peg,* as she
invariably calls the vessel, two years later. Because of the punishing hours she
worked, Hepburn ended up sleeping on board; when her daughter, Alice,
arrived in 1990, it seemed only natural that *Peg* should be her home, too. Amid
the clutter of the darkened interior, filled with cardboard boxes bulging with
nautical spare parts, remnants of a happy domestic life can still be seen: A tiny,
gold-sequined child's purse sits on a window ledge; the doorframe to the rear
cabin is notched with records of Alice's burgeoning height.

 Like many people who lead unorthodox lives, Hepburn seems nonplussed
that anyone might find her personal and professional arrangements unusual.
When asked how exactly one looks after a young child on a working boat, she's

straightforward. "We had a big brass hook—a snap hook—and she'd be over the door in the galley, swinging in the doorway, or she'd be up in the wheelhouse. We hung her up outside and inside and everywhere. She was little and just sort of goo-goo, you know?" Alice herself, it seems, is equally nonchalant about her past. "She's a teenager, so forget it," says Hepburn dryly. "She's like, 'Ma, I am *sooooo* not interested.' And that's okay."

Visit with Hepburn for only a few minutes, and a number of preconceptions explode quickly. The first is that she must be abrasive and blue collar—what other kind of woman would pursue a life like hers? Although there is an undoubted toughness to her, she comes across as more girlish than anything else, an effect aided by her language, which is sprinkled with the "likes" and "kind ofs" that are the inevitable result of raising a teenage daughter. She is also, it turns out, far from being blue collar: As the daughter of a successful maritime

With her chunky, maternal lines, Pegasus seems like a quiet rebuke to the frenetic commercialism that surrounds her.

architect from Concord, Massachusetts, she "grew up on yachts" along Boston's exclusive North Shore. But the biggest misconception would be to think Hepburn entered the almost entirely male world of maritime commerce to make some kind of feminist point. Her nonchalance about raising a child on board a tug is equaled only by her nonchalance about being a female tugboat captain. Every attempt to probe her on the gender issue is met with impenetrable elusiveness, not so much a denial that she faced hard times from men as an utter lack of interest in making a play of it.

Part of this attitude stems from Hepburn's enormous good fortune in finding a man as sympathetic as Captain Dick Forster to "break in" with, as the

maritime apprenticeship is termed. Her voice changes noticeably when she talks of him, becoming both faster and more tender. "Oh, Dick is just a love," she says. "He's very, very, very good at what he does. I learned really well, and I feel my background with him was probably more solid than most people were able to get."

Hepburn began her happy tutelage with Forster by chance, when her "best girlfriend," Bettina, got a job working as a cook on board his boat. Hepburn seized the opportunity to wrangle a position as a deckhand. Her early days, spent mostly along the New York Canal system, sound like the most contented of matriarchies: "We had such a blast. Dick's daughters came on the boat and Bettina was the cook, and it was always just fun, you know? And we'd stop, we'd tie up to a tree and we'd drink and have fun, and then we'd go to work, and we worked really, really hard, but we'd always play. I was able to get on the boat in a nice, gentle, friendly way."

As Hepburn recounts these memories, she is in constant motion, prowling from one end of *Peg*'s deck to the other, in and out of the galley, pausing to examine small pieces of rope or an oil-covered bolt as though at a yard sale. In the aft a young male volunteer, one of Hepburn's "Rustbusters"—her term for the loyal volunteers who help preserve *Peg*—is busy attacking a mooring cleat with a wire brush. Hepburn retired in 1998, placing her old floating home on the National Register of Historic Places (she and Alice moved into a Tribeca apartment) and establishing *Peg* as a nonprofit educational resource for children. Right now *Peg* is in bad shape, barely seaworthy, and Hepburn attempts to corral anyone—writers doing pieces on her, tourists casually leaning over the rail—into giving a helping hand. But it is her Rustbusters who are at the heart of the effort. As she talks another of them shows up, a middle-aged man with a moustache and nervous smile. "This is Dave!" says Hepburn, clapping him on the arm. "Dave came down from Queens County just to be here. He's tugboat crazy; he can't help it." She spends the next ten minutes carefully organizing his efforts—"That's a tap and die set. Put that on deck. Is that a torque wrench, do you think?"—before starting to rummage distractedly in a box of objects wrapped in newspaper.

If all goes well, a trip to Albany is planned with six children on board. Hepburn and her young crew will venture up the same route she first traveled as a young woman with Forster and Bettina nearly twenty-five years ago. But there's a lot to do before then. *Peg* needs a mast installed (Hepburn has already found "a really cool, super-long one" salvaged from another old boat); more importantly, she needs a trip to Garpo Marine in Tottenville, Staten Island, where she will be gingerly hoisted out of the water so that a welding crew can rip her open and check every bulkhead for damage. "It's a nightmare," Hepburn says. "It's dirty, filthy work. Very bad. . . ." She pauses for a moment, rubbing her hand over the fat, paint-blistered bumps of the hull's riveting, and smiles happily to herself.

■　■　■　■

Pegasus underwent extensive repair to her hull at Garpo Marine in 2004. She is now seaworthy and back in New York Harbor, where her deck and engine room are being worked on. Hepburn expects onboard educational programming to begin in spring 2007.

GERRY WEINSTEIN

Steamboat Preservationist

On a gray, late fall morning, Gerry Weinstein stands on the deck of his 1933 steamer, *Lilac,* forlornly folding a large coil of rope. It is a "volunteer Saturday," but so far he is the only one to have materialized. Behind Pier 40, where *Lilac* is moored, the Hudson laps darkly and the skyscrapers of Jersey City rise in a series of youthful peaks. To the right, along the Greenwich Village waterfront, Richard Meier's high-priced glass triptych of condominium towers answers back. Weinstein is a slight man in his fifties, clad in glasses, a blue beret, and jeans. He seems an unlikely candidate to have taken on, virtually single-handedly, the task of returning this 173-foot-long, 800-ton hunk of metal to life, an impression that is confirmed by his first words. "I have a theory about enterprises like this," he says. "New York is actually the kiss of death for them. Our chances of getting it done radiate out in concentric circles the further you get from here."

Weinstein has sound evidence for his theory. Long before he and a group of other maritime buffs purchased *Lilac* in 2003, he had been involved with other attempts to restore historic vessels in New York Harbor, beginning with the 1918 steam lighter *Aqua* in the mid-1970s. The project failed, and eventually *Aqua* was towed away to Brooklyn to be scrapped. Two other steam vessels Weinstein worked on, *Mathilda* and *Catawissa,* ended up going to Kingston, New York. But Weinstein's greatest loss was the World War II Liberty Ship *John W. Brown,* which ended up on the James River in Virginia in 1983 after a futile five-year bid to restore her in New York (the ship now resides in Baltimore). "When they towed her out of here, I cried," he says. "I thought, 'Another failed project.'"

Despite these setbacks, Weinstein remains undaunted. Listening to the urgent, enthusiastic rhythms of his speech, one is reminded of a similarly

"Imagine working down here in the boiler room when the ship was going. There'd be four or five men at least, and in the summer it could reach 110 degrees."

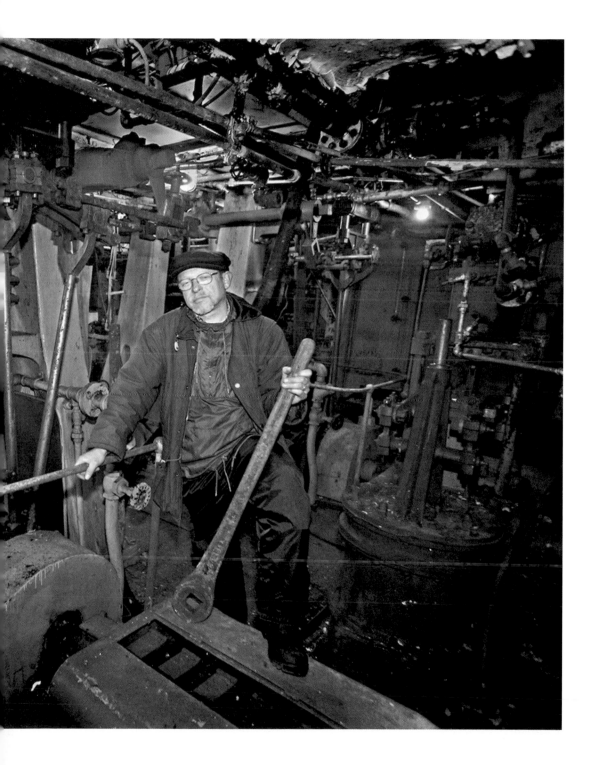

obsessed New Yorker: Weinstein loves steam the way Martin Scorsese loves film. Weinstein's sentences tumble into each other with barely a pause for breath, and he imbues such terms as "triple-expansion engine" and "surface condenser" with the sensuousness of a lover. It took a dream, he says, to persuade him to finally bite the bullet with *Lilac*. "When we were looking at her, I dreamed I was in the engine room and there was this magnificent triple-expansion engine that someone had started to restore, and they had wrecked it with a cutting torch. And I thought that maybe this was a sign that we can't let this happen again." Weinstein clearly has no doubt that he did the right thing.

Lilac was originally a U.S. Lighthouse Service ship; she worked along the shoreline in Philadelphia, and later New Jersey, maintaining the oil-burning buoys that guided navigation. Her deck is handsomely scalloped from the impact of buoys being heaved on board, and a section of her bow slides back to lower them overboard. She was later a Coast Guard vessel, with a crew of more than thirty. After being retired in 1972, she had a checkered career as a training vessel for the Seafarers International Union on the Potomac, followed by a sad twelve-year stint as a floating real estate office in Virginia. Weinstein has only recently removed the rotting carpets, push-pin maps, and plastic phone jacks that cluttered up her quarters from this period.

Weinstein hopes to raise $400,000 to restore *Lilac*. He has applied for a state grant, but this sum would have to be matched by private and government funds. In addition, he calculates that it will require at least 40,000 hours of volunteer work to restore the vessel to her self-powered glory again. "I'm a realist, though," he says. "I see it as being quite possibly not done until after I'm gone. But that would still give me great pleasure, you know?"

It is, of course, the engines that most appeal to Weinstein. He eagerly leads the way belowdecks to them. We pass the captain's cabin, a tiny chamber with a metal bed frame and the smell of rotting wood, and the crew's bathrooms, a row of cracked porcelain toilets in cubicles, now all doorless. These small domestic details radiate a powerful sense of lives past. The engine room is enormous and lit by three bare bulbs. Weinstein is in his element here, turning this way and

that to point out things. "The engine is actually in great shape," he says, "and so is the hull. Some boats you can literally punch a fist through the hull, it's that rotted away." The elegant steel cylinders of *Lilac's* twin engines rise in tandem, looking as sleek as if they were made yesterday.

The real problem lies in the boiler room, Weinstein says, where the "cake asbestos" that insulates the twin boilers will have to be very carefully—and expensively—removed. "We shouldn't spend too long in here," he says, as he forces open the wheel lock to the boiler room door with a metal bar. Stepping inside offers the eerie sensation of being in a deserted reactor chamber, which is essentially where we are. Pieces of asbestos lie in clumps on the floor, and the boilers stand squat and peeling in front of us, issuing a direct challenge. "Imagine working down here when the ship was going," says Weinstein. "There'd be four or five men at least, and in the summer it could reach 110 degrees." Quickly, he steps back out and slams the door shut.

Restoring old boats is an expensive hobby, even when the cost is shared among fellow ship lovers, but Weinstein has been fortunate in his business life. His maternal grandparents, Abraham and Lillian Rosenberg, founded a hardware business in 1922 later known as General Tools, an enormously successful manufacturer of specialty tools. Weinstein has been involved with the business in one way or another since he left college. "My parents basically said, 'Do whatever you want, but also take over the company,'" he says dryly. General Tools has a CEO who "does the main work" while Weinstein, who has been the chairman since 1990, concentrates on "long-term strategic planning." The arrangement allows him both the time and money to pursue his private passions. He has proved to be a generous friend to the maritime restoration community, providing tens of thousands of dollars not just to *Lilac,* but to other historic ships in New York harbor such as the 1907 tugboat *Pegasus,* moored nearby. "I always say the money my kids would have got for their education goes on these things," he says.

Weinstein's love of ships developed early in life, via a certain grisly twist of fate. His father, Seymour, photographed B-24 bombing raids in Europe for the U.S. Air Force during World War II and later took images of crash investigation

sites. On one such investigation he had to photograph the charred remains of a good friend. As a result he developed post-traumatic stress and determined never to fly again. "But meanwhile," says Weinstein cheerily, "he was in France and Italy, and he loved it, and so starting in the 1960s we went to Europe. And because he wouldn't fly—guess what? That left the Cunard line." The teenage Gerry Weinstein became accustomed to traveling on *Queen Mary, Coronia, France,* and the other grand steamers of the day. "I really loved those ships," he says. "One time we were on the bridge of *France* leaving New York Harbor, and way off in the distance was a smudge, and I sort of said out loud, 'That sure looks like the *Bremen,*' and sure enough it was. The captain couldn't believe it. It was a total wasted youth, you know? While other people were dating girls, I was identifying ships."

"While other people were dating girls, I was identifying ships."

It would be easy to pigeonhole Weinstein as simply an enthusiast, but a visit to his company's office reveals a man of truly complex sympathies and devotions. General Tools, as befits its chairman's interests, consists of a landmark cast-iron building in Tribeca that has been untouched by the hand of modernization. Packing clerks bustle about between chipped metal filing cabinets on the ground floor, and the simple lobby consists of a set of creaking stairs rising steeply to the offices above. Aside from a pile of UPS stickers, the clock seems to have stopped in the late 1930s. Weinstein occupies a wood-paneled office on the second floor, decorated with an oil painting of his grandparents on one side and numerous prints of steamships on the others. He exudes not one iota of a corporate chairman's sense of entitlement; in fact, in his short-sleeve yellow shirt with a General Tools logo on his chest, he resembles one of the shipping

clerks below. He wends his way through the maze of cubicles to the back of the office and takes an elevator to the floor above, which hosts his private "photo studio." Immediately, another side of him becomes apparent.

Weinstein, it turns out, is something of an artist. Along the walls are a series of beautiful black-and-white photographs of an abandoned industrial behemoth, weeds pushing up through cracked concrete floors, factory windows gaping open, the stubs of chimney stacks peeking out from behind clumps of trees. Weinstein took these pictures, and the cumulative effect is one of aching romance. "That's the old Ford plant that was in Edgewater, New Jersey," he says. "Those photographs ended up in the Library of Congress." In addition to being a businessman and maritime preservationist, Weinstein is an "industrial archaeologist," taking photographs and writing detailed written reports of important industrial sites before they are obliterated forever to make way for highways, megastores, or, in the case of the Ford plant, condominiums.

In this career Weinstein has photographed such objects as the last Staten Island steam ferry, the power generators at Grand Central Station, and a host of electrical substations for the Metropolitan Transit Authority. The latter were the subject of a Transit Museum exhibition in 1990, though Weinstein says he is not much concerned about showing off his photographs. "The satisfaction for me is in documenting this thing and knowing I'm part of the process of documentation, and also that I've taken the best possible photograph anyone could take, so that 500 years from now, anyone looking at this thing can read the boiler plate, say, and know that such and such a company made that thing. That's the satisfaction for me."

One might expect Weinstein, with his proximity to and love of all things mechanical, to have an engineering background, but this is not the case. "Oh, no, I was actually a complete flunky at science. I had dyslexia, and I couldn't do math, couldn't do science. I actually hadn't yet been accepted into college and the Vietnam War was raging. It was scary." Weinstein finally ended up majoring in theater and history at a Quaker college in Ohio before the gravitational pull of the family business brought him back to more somber endeavors, but he

obviously is delighted by the way his life has turned out. "I ended up being something far better, a historian of engineering. Engineers have to specialize—you could be an engineer, and your whole life could be spent designing channels for water flow. What could be more boring than that? I get to study ships, power stations, factories, piers. I get to do all this kind of stuff as a historian as opposed to being an engineer."

As with many people who have overwhelming passions, Weinstein makes little, if any, distinction between his personal and professional lives. Any time he has left over from General Tools, his documentation work, and *Lilac* he spends traveling the world with the Society for Industrial Archaeology, an organization that visits factories and industrial sites both ruined and fully functioning. His wife, Mary, is the president of the local chapter. "We actually met at an industrial history conference in Quebec," he says. "And next week we're going to Bologna for an industrial history tour. We're going to see Ducati, Lamborghini; we're going to see a factory that makes knitting machines, a factory that makes ice cream machines." His voice rises dreamily. "Actually, the best stuff I hear is in the Urals. There are still Bessemer Converters operating in the steppes. They say *that's* where to go to see industrial archaeology. . . ."

Lilac will remain moored on the Hudson, awaiting his return.

SAL POLISI

Nautical Wood-Carver

"Oh, God, the stuff you see here!" says Sal Polisi. He is standing in his work-shop, consisting of two metal shipping containers welded together, looking at the East River waterfront just south of Pier 17's jaunty red silhouette. Behind him, the FDR Drive thrums away on its battered steel supports. It's early in the morning, and the Fulton Street Fish Market, just two weeks away from its last day of operation in this location, is winding down after the night's activity. An old Chinese man cycles by, a fishing rod under his arm. Across the river in Brooklyn Heights, a church spire rises darkly.

Polisi is talking about how his workshop—which is officially known as the Maritime Craft Center and is part of the South Street Seaport Museum complex—makes an ideally anonymous place from which to view the life around him, so much so that plainclothes police have used it as a lookout. "One time they were here," he says grinning, "and we're standing around talking, and this guy comes over and starts taking photographs of this very attractive woman. All of a sudden she *disrobes,* and he's taking these fast shots of her. The *fun* those guys had shooing them away . . ." He laughs deeply. With his dark hair, youthful appearance, and New York accent, Polisi, who was born in 1935, bears more than a passing resemblance to the late actor Jerry Orbach, and the scene might well be a lighter moment from *Law & Order.* It's easy to imagine Polisi comfortable around police officers—around most people, in fact. Tough yet gracious, solici-tous, and ever ready to crack a joke, he is unquestionably a people person.

Polisi put that skill to work as a personnel manager for many years, then later as a plant superintendent at a manufacturing company in Melville, Long Island, that made high-speed cutting equipment. He started there in the mid-

1950s as a machinist, after spending the Korean War on an aircraft carrier (he enlisted at seventeen), and quickly became active in the local Teamsters union. Dealing with people, handling the daily ins and outs of corporate diplomacy, came naturally to him. "We had a wonderful relationship," he recalls, "very few grievances that went to arbitration. Everything was settled in the company."

Polisi had long had an interest in drawing and the arts, something his grammar school teacher had noted when he was growing up in East New York. He had designed division insignias for his aircraft carrier crew during the war, and later, married and working on Long Island, he took evening classes in drawing and sculpting and even a series of wood-carving classes with a teacher in Huntington. In 1983 he joined the South Street Seaport Museum's educational program, working as a volunteer carver at the newly established Craft Center on the weekends.

He built from scratch a new figurehead for Wavertree, *first making a clay mock-up from a life model. Later, he added a double chin "because we were creating an 1885 woman."*

It was a perfect relationship: The museum got a skilled draftsman and carver who could work on various restoration projects, as well as one who could be relied on to interact well with the public, while Polisi got to "clear his mind out" doing something he loved.

Shortly thereafter, however, things started to go wrong for him. First, his company was purchased by a British group that relocated it to the South. The new owners asked Polisi to follow, but he "saw the writing on the wall" and declined. (His "comrades" who accepted the offer—Polisi uses the term several

times, a legacy of his union days—were all let go a year and half later.) Then Polisi got divorced and at the age of fifty, after a lifetime of work, found himself adrift and without purpose. He recalls wandering the local shopping mall, his morning coffee in hand, and realizing that he was imitating his old behavior at work, where he would travel from person to person at their machines. "What I was missing was people," he says.

It was at this point that his activities at the Craft Center took on a new importance, anchoring him in a firm routine. Polisi made a small apartment for himself in his house and rented out the rest of it; he began working seven days a week at the Center, often until 9:00 or 10:00 P.M. To make ends meet, he took on private carving commissions, such as bar and restaurant signs, in addition to his museum work. (He has since made such objects as a 6-foot lobster for a seafood restaurant and an oversize pair of teeth for a dentist's office, a model of which still sits on his crowded work desk.) At the time, he shared the Center with five model makers (there is now just one) who crafted things such as ships in bottles and helped restore pieces in the museum's collection. The atmosphere was one of contented fraternity: "We'd work; we'd stop. We'd play a game of chess; we'd listen to the opera. I'd cook some food and bring it down. People would come in, and they'd be jealous. I'd get people from Wall Street wanting to exchange jobs!"

Slowly, Polisi got his life back. He also acquired new skills, learning from the carpenters working on board *Wavertree* and *Peking,* two sailing ships the museum owns, and from the museum's historians. He repeats one of the lessons they taught him about reproducing elements from these ancient vessels: "You don't make it better. Everything has to be the way it was before. If there's a flaw in it, they want that flaw in it." Polisi carved teak benches for *Peking.* He also restored a magnificent gold eagle that once stood on the wheelhouse of a tugboat and is now a prized part of the museum collection. Perhaps most famously, he built from scratch a new figurehead for *Wavertree,* first making a clay mockup from a life model. Later, he had to add a double chin to the model "because we were creating an 1885 woman," he explains with a smile.

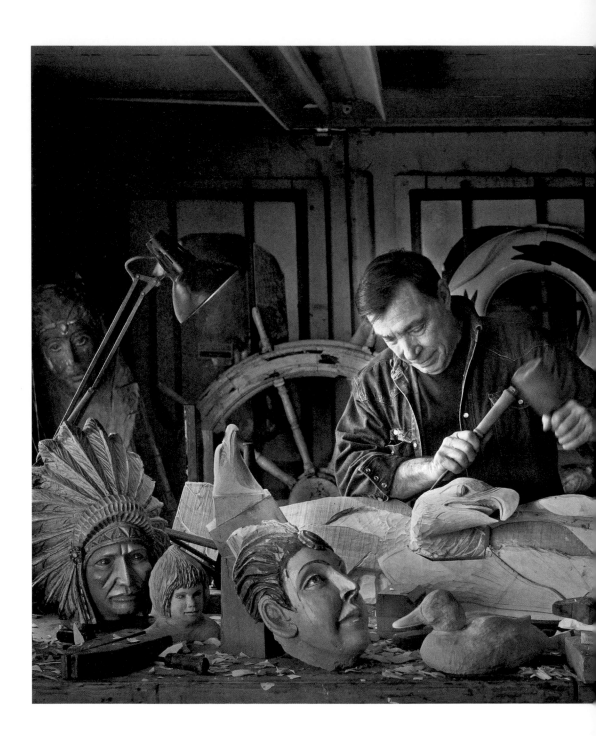

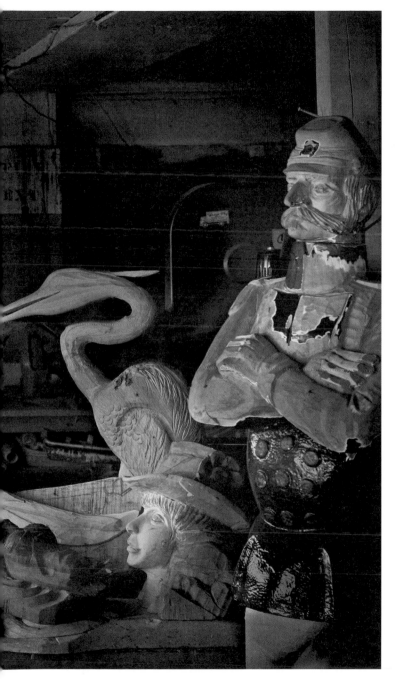

The museum got a skilled draftsman and carver, while Polisi got to "clear his mind out" doing something he loved.

The workshop also helped Polisi in another way. One day a woman named Susan Kayser, who was working as a volunteer on the schooner *Pioneer,* came in to borrow some tools. He was "a little huffy" to her at first, he says—or rather, that's how Kayser, who became his second wife a few years later, likes to describe his behavior then. Polisi believes he was merely flirting. "I said something like, 'You make sure you return them, because that's how I make a living, you know?'" Kayser is a successful health law attorney who offers seminars around the country, and she clearly knows her man: In 2005, for his seventieth birthday, she gave him the perfect present—a trip to Italy to work with an Italian master carver. Polisi, rubbing his cheek, says he still can't believe she chose him. "Her parents gave her all that fancy education, and she went and married a Brooklynite," he muses.

Nowadays, Polisi, who lives in Merrick, Long Island, near the former factory he used to work at, comes in at around 7:30 A.M. to beat the traffic and stays until around 2:30 P.M. If the weather is good, he'll work outside, wheeling his latest piece out on a dolly. He uses very simple tools, mostly chisels of various sorts, and only rarely employs electrical implements. "If you use electric tools like a Dremel or electric sander, you're disappointing the people who are coming to see you. People say, 'Well, in the old days they didn't use them,' and I tell them, 'But if they'd had 'em, they would have used 'em,' and then you get into these long conversations where they never end. So it's easier to use the chisel and chop away, and everybody is happy." He laughs.

Surprisingly, the crowd is "half and half," split between tourists and New Yorkers. "A lot are New Yorkers that come and want to be reintroduced to New York," Polisi says. "Sometimes they get a little insulted if I hand them a map telling them about New York, but they don't really know about New York." If people ask him, Polisi is happy to explain how he parlayed the misfortune of being laid off into a full-time position he loves. "They can relate to me to some degree, because a lot of times they've lost their job, too—it's happened to them." Inside the workshop Polisi keeps a visitor book in which he encourages people to write in their native tongue. There are entries from Wales, Rus-

sia, Seoul, and even some Arabic curlicues in blue Biro. Under the "Comment" heading, the Russian entry says simply "Too friendly!"

Polisi doesn't know how long he'll keep working at the Craft Center. He is a volunteer, so the museum's financial ups and downs, of which there have been many in recent years, don't really affect him. But the area is changing rapidly. The fish market is destined for the Bronx, and already the neighborhood surrounding the museum is in a frenzy of gentrification. Beeckman Street and Peck Slip in particular are full of new residential buildings in brick and stone, inserted carefully between their Federal-era neighbors. Construction crews are everywhere, and several facades announce new eateries coming soon, including a brick-oven pizza place near the venerable, century-old Carmine's Seafood Restaurant.

Polisi's shipping container of a workshop may well flourish under such gentrified conditions, and Polisi himself does not seem too worried about what may happen—partly because right now, there's just so much life to see. He turns and gazes out of the window at a young Asian man doing tai chi. "This guy's been here for years," he says. "One day two good-looking girls go up to him, and they're trying to follow what he's doing step by step. He doesn't even *smile*. Just continues on. Boy, I would have took that and run with it!"

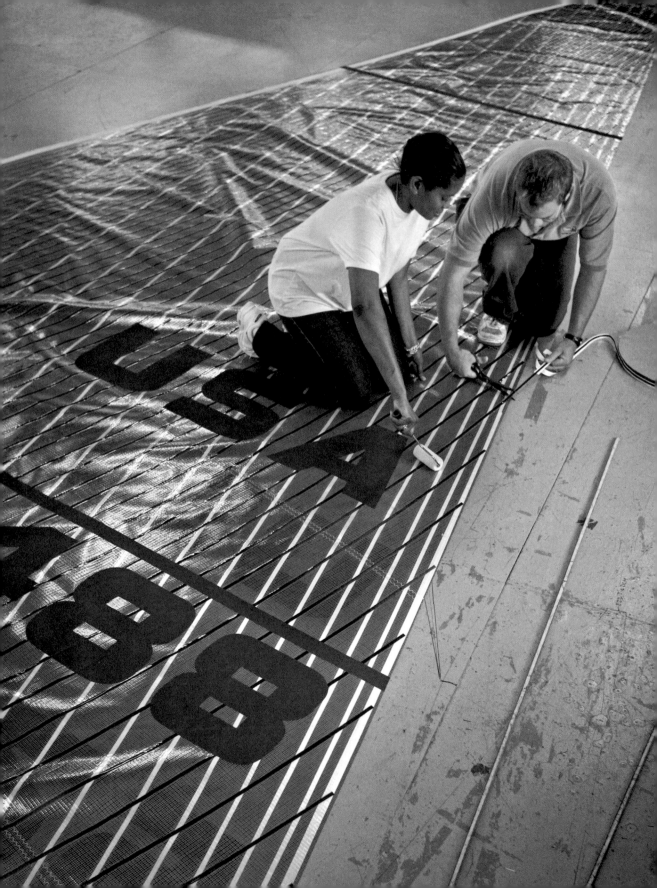

UK-HALSEY SAILMAKERS

Sailmaking Company

City Island is a tear-shaped splotch that hangs off the southern edge of Pelham Bay Park in the Bronx, where the Long Island Sound meets Eastchester Bay. Its only connection to the mainland is a bridge, and it is more easily accessed by boat. Like Coney Island in Brooklyn or Beach Channel in Queens, City Island offers the delicious sensation of being a town within a town, in this case a small New England seaside resort. It's a shock amid the briny air, wooden Victorian homes, and squawk of seagulls to see the familiar green street signs and realize that one is still within the vast embrace of New York City.

The island's spine is City Island Avenue, the central thoroughfare that runs north-south and on which UK-Halsey Sailmakers is located. Like most of the buildings on the avenue, it's a loveless box of a building (the Victoriana is generally reserved for the side streets) and belies any romantic notions attached to the idea of sailmaking. The company's president, Charles "Butch" Ulmer, however, is the personification of a yachting professional: solid, massively calm, with a tanned face and steel-gray hair, leather loafers, and a large ruby and gold class ring on his finger. It's easy to imagine him at the helm of a yacht, guiding it masterfully amid the sea spray and shouts of crew; indeed, he is a highly experienced and much respected sailor who has sailed all over the world and spends a substantial amount of his time out on the water with clients, testing his products under the most grueling of conditions. Beneath his desk his black Lab, Patrick, slobbers contentedly, occasionally arching his neck to lick the nearest available hand.

Ulmer is a third-generation "clamdigger," as those born and bred on the island are known, and so are several of his staff. He grew up "one house in from

the water" on Buckley Street, only a few blocks away from where he now does business. His father taught him to sail at an early age; by the time Ulmer was five, he already had his own boat. His sales and staff manager, Tom Nye, was also born on the island and is its official historian; Tony Italiano, the company's seventy-five-year-old "benchman" who hand-sews the sails, has worked for various sailmakers on City Island since he was in high school. City Island keeps its children close, and despite the recent enormous influx of new residents, drawn by its civilized way of life and proximity to Manhattan, it still maintains a familial sense.

City Island offers the delicious sensation of being in a New England seaside resort. It's a shock to discover that one is still within the vast embrace of New York City.

What has changed is the degree to which City Island now depends on the nautical businesses that were once its lifeblood.

"When I grew up here, post World War II, it was strictly boat-building, sailmaking, and yacht clubs. That was it," Ulmer says. "And the population of City Island, apart from the local dentist and doctor, say, was made up of people who worked in the boating industry. Now, given the capital requirements for a boatyard, they just can't stay in business in New York City." He points to a boatyard across the street, visible through his office window. "Consolidated is closing now. If it isn't condos in two years' time, I'll eat your hat." Being the businessman he is, Ulmer seems to take this change in his stride. "It's just a natural process, you know, real estate being what it is. And this joint, it's going to follow without any question."

Not that UK–Halsey is unprofitable. Ulmer, who took over the business from his father, has overseen its conversion from a low-tech industry of hemp and cotton "where everything was done by eyeball" and sails were laid out on the floor with ball and twine to an astonishingly high-tech enterprise of computer-designed and -cut sails crafted from such materials as Kevlar, Mylar, Dacron, and carbon-fiber. The company's Web site is full of diagrams, technical explanations, and photographs of swatches being wrenched under pressure, and its product names—Tape Drive, the Matrix Cut—have a snazzy, cinematic zip to them. All this comes at a price, of course. Ulmer points out a photograph on the wall of a sleek yacht, its multicolored sails billowing, gliding over an aquamarine surface. "That's *Congere*. That picture was taken in the late 1980s off Hawaii, and the inventory on that boat cost $300,000 then, just the sails. Today, that inventory would be $750,000." Customers who come to UK–Halsey are not only deep of pocket but also highly competitive, though, as Ulmer diplomatically puts it, "the connection between affluence and sailing ability can be a pretty wide gap."

Behind the front offices lies the "loft"—the large open spaces where sails are made. The term derives from the original process of sail- and boatmaking, called "lofting," where craftsmen would literally lay out a full-scale map on the floor of the vessel they were working on. The linguistic scrap is one of the last remnants from the business's old days. Taped to the glass panel that runs alongside one wall of the loft is a notice that says NO STREET SHOES. ("Don't leave 'em where Patrick can get them," warns Ulmer. "He loves shoes.") Inside, a number of men and women carefully unfold triangles of shiny material as though working on a giant jigsaw puzzle. Around the edges of the floor are a number of small pits, like those for a stage prompter, in which industrial sewing machines are set, allowing those working on the sails to sew without having to pick them up. With its bright fluorescent lights and the gentle whine of FM radio, the place might be a clothing factory rather than a nautical industry; only the satisfyingly mysterious labels attached to the ceiling racks and storage cabinets that read SPINNAKER CLEW, DUTCHMAN PARTS, and BRAIDS MEDIUM suggest otherwise.

Rick Sinclair, UK-Halsey's service manager and a fourth-generation sail-maker, "runs the girls" who do the sewing, as Ulmer puts it. The sails are designed here using UK-Halsey proprietary software, but they are actually cut in one of the company's other lofts (the company is part of a loose conglomeration of about forty other such lofts around the world) and then assembled on City Island. The "girls"—America Ortiz, Leonides Jiminez, and Susane Mottley—are relaxed and friendly; their attitude and longevity at UK-Halsey (Jiminez has been here since 1980, Mottley since 1994) speak to the sense of camaraderie the company engenders. Sinclair points out the crisscrossing black and white stripes that checker the sail Mottley is laying out. "Those tapes are going over all the different stress points of the sail. It's all computer designed, so there's no load-bearing seams. This sail is almost indestructible; it will never lose its shape—in fact, we've never had a sail that's failed from side to side," he says. In the far corner, where Ortiz is working on another sail, comes the staccato burst of a sewing machine as one panel is attached to another.

Men and women carefully unfold triangles of shiny material as though working on a giant jigsaw puzzle.

There is one area of the loft, though, where a touch of the old days still remains. Sitting on a tree stump (the favored seating arrangement of old-time benchmen) is Italiano, white-haired, bespectacled, and hand-sewing cleats to the edge of a large orange Dacron sail. Around his right hand he has what looks like a miniature leather saddle, known as a "palm," used for pushing the needle through the many layers of material that make up the sail. This is work that cannot be done by machine. His right index finger is bent at a sharp angle,

though not, it turns out, from years of dedication to his craft. "It's from bowl-ing," he says. "I'm a big bowler; I still bowl three or four times a week." His eyes are patient and amused.

Italiano remembers the days when sails were made of cotton and rope of tarred hemp, and when everything was sewn by hand. Rope had to be hand-spliced in an ever-diminishing process known as "tailing" so that the joins were invisible. "That's when it used to be a really interesting business, and they used to call it an art, and it *was* an art. You had to have a little bit of the artist in you to do it," he says. Like Ulmer, however, he seems quite unsentimental about the past despite his attachment to it. Although he officially retired at the age of sixty-five, more than a decade ago, he still enjoys working at UK-Halsey and readily admits that working with man-made fibers, in particular Dacron rope, is much easier than using hemp, which is softer and has more give to it. "But talk about a dead art. There's one guy I worked with on City Island, he's retired a long time, he could do this. And I have a guy who was my best man, lives down in Florida, he's probably eighty now. But outside of us three I bet you there isn't anybody else who could do a lot of the work we do." As Cher's voice blasts another power ballad over the radio, Italiano bows his head and gets back to work.

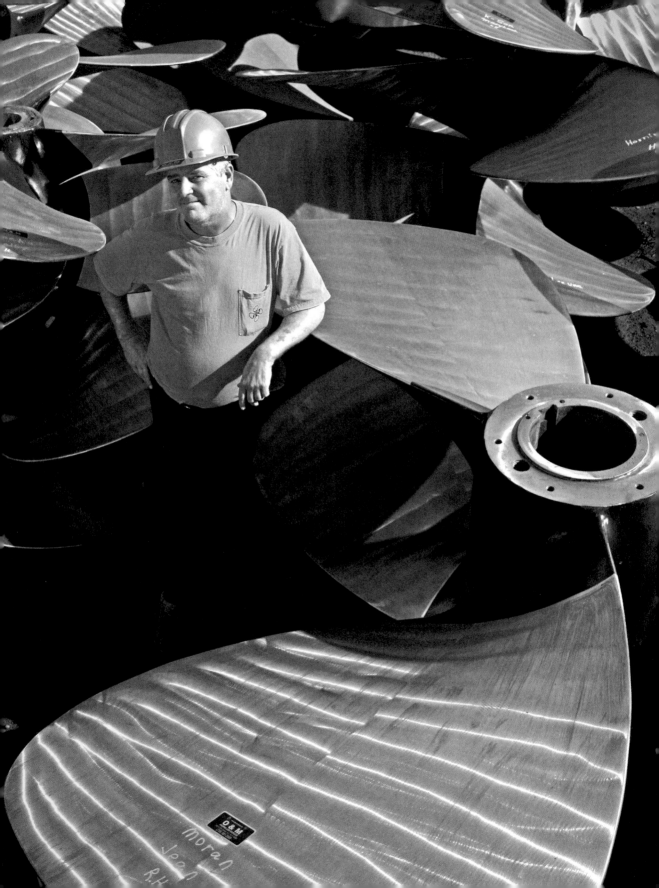

BOB WEAVER

Ship Propeller Repairman

Encountering O & M's storage yard for the first time is a bit like stumbling upon the remains of some ancient civilization buried amid the detritus of an indifferent age. There, at the southern tip of Staten Island, overlooking the oil tanks of Perth Amboy across the Arthur Kill, on the other side of the railway tracks leading to Tottenville Station—"the end of the line"—past the signs for Lil Suze's Hair and Nail Salon and an Atlas Gym, surrounded by a chain-link fence and guarded by a sleepy German shepherd, stands a pile of gleaming treasure: a mass of sculpted bronze and steel curves that catches the early morning sunlight.

The treasure consists of ship propellers, about 150 of them, piled on top of each other on a cracked blacktop surface that is slowly sinking under the weight. The largest ones are nearly 12 feet in diameter and weigh more than 11,000 pounds. Most of them belong to tugboats, but a few are from fishing boats, pilot ships, and even the odd pleasure craft. Scrawled across their blades are the names of their owners or the ships they belong to—SANDY HOOK PILOTS, BUCHANAN, MORAN, DOROTHY B, SEA FOX. The majority have already been repaired, or "reconditioned," as it's termed, but the massive gouges and contorted angles of the blades on some of them bear witness to the violence of the underwater impact that has brought them here.

"There's no such thing as propeller school," says O & M owner Bob Weaver, standing in the company's large concrete-block workshop adjacent to the storage yard and holding his trademark cigarette behind his back like a guilty schoolboy. "You can't study for it. You just gotta pick it up, and not everybody's cut out for it." Weaver, who works with a childhood friend from Staten Island, Joe Ciccariello (they grew up on the same block), and assistant Pedro Gonzalez,

has a slightly forlorn way of speaking, and an ironic half-smile plays continually across his lips. Before he joined O & M as a seventeen-year-old in 1975, he'd led a self-described "hardscrabble" life.

"My dad basically left us when I was ten. He wasn't much of a dad," Weaver says. "I was always hustling, you know? Shining shoes, doing odd jobs, always looking for ways to make money. Nothing illegal, but always hustling." The cofounder of O & M, a Dane named John Overbye (the O in "O & M"), took on young Bob and taught him the basic welding skills required. In January 1986, when Overbye decided to retire, he asked Weaver, who by that time had become foreman, if he would like to buy the company. "I had no preparation, nothing," says Weaver. "Suddenly, wham! That was it." Almost overnight he was forced to learn such tasks as book-keeping, payroll, and the thousand and one

"There's no such thing as propeller school. You can't study for it. You just gotta pick it up, and not everybody's cut out for it."

other bureaucratic bits and pieces that go with running a small business. A few months after taking over, he hired Ciccariello. If Weaver is the quiet, world-weary one, Ciccariello is his opposite, garrulous and outgoing (Weaver describes him tolerantly as "a ham"). "We work good together," says Ciccariello. "We yell and scream at each other sometimes; we get on each other's nerves, but . . ." He trails off happily.

Reconditioning a "wheel," as the propellers are called, is as much an art as a science. It takes considerable skill not only to perform the delicate work of straightening, welding, and grinding out the finished product, but also in many cases to assess what the damage is in the first place. "Sometimes it's obvious—the blade's twisted up ninety degrees or something," says Ciccariello. "But

sometimes you can't see it, especially on a big wheel. You got a blade that's 4 feet long and the tip of it's out 2 inches—you don't notice it." Weaver nods in agreement. "Every wheel is different," he says. "The damage is never the same."

New York's waters are not friendly places for ship propellers. For one, they're full of flotsam, including waterlogged telegraph poles that float just beneath the surface, and there are plenty of shallow areas where even a skilled captain can run aground. "People think there's just dirt at the bottom of the ocean," says Ciccariello, "but there's a lot of granite, a lot of stone. It can chew up a wheel bad." Ice is also a problem on the East Coast; a submerged block of freshwater ice working its way down the Hudson from the Great Lakes can have the same effect on a boat as running into a concrete block. Often, the damage is not limited to the propellers alone. "You got a big, thick wheel hits something hard enough," says Ciccariello, "you can bend the shaft, you could knock the strut out of whack, you could blow the entire gear box apart with the shock. It's happened."

In order to minimize the damage from such collisions, some ships use bronze propellers—usually a mixture of manganese and bronze or nickel, aluminum, and bronze—which are softer and more absorbent under impact and also less expensive. The problem is that, while bronze can prevent the transference of shock to other parts of the engine, the propellers themselves tend to get damaged much more quickly. It's generally considered wiser to use stainless steel, which is about five times as strong though considerably more expensive to recondition. About 90 percent of all the wheels Weaver sees are now stainless steel, a marked increase since he started in the trade some three decades ago.

It takes ingenuity to manhandle these great chunks of metal. Weaver was fortunate to inherit a number of devices that Overbye designed specifically for that purpose, including a hydrostatic balance for propellers—essentially a giant spindle on which a propeller is mounted to determine if its blades are equally weighted—and a wrench of comical proportions that looks like a sign for a hardware store but is capable of bending out even the most intractable of twisted blades. The wrench is entirely hand-ratcheted. "You could have an electric one,"

says Weaver, "but then you'd have no feel. When you're doing it by hand, you know exactly how much tension you're putting on there." Sometimes, says Ciccariello, it exerts so much pressure that it begins to pull out from its moorings in the floor, and he has to lag them back in again. In the corner there's also a five-ton-capacity electric crane that is used to lift wheels into position.

When a new set of wheels arrives in the shop (most tugboats have two), the first thing Weaver does is check out their "pitch" and "tracking." The tracking of a wheel is the overall length of each blade from hub to tip; its pitch is the angle of each of its blades (there are usually four, but new designs increasingly incorporate five).

Reconditioning a "wheel," as the propellers are called, is as much an art as a science. Every wheel is different. The damage is never the same.

If the pitch is off by only a couple of inches, it can set off a serious vibration. Cracks and dents are marked in red dye and circled with a Sharpie pen. Some of these flaws are obvious at a casual glance, but sometimes they consist of hairline "stress cracks" that are harder to pinpoint. Ciccariello believes that such damage occurs when the wheels "hum" in operation, that it is the result of sonic vibrations rather than any actual physical contact. As he talks about this matter, his voice rises with enthusiasm; it's clear that this is far more than just a job to him.

Once the damage on a wheel has been identified, Ciccariello goes to work with his welding tools. He will cut off a maximum of one-third the length of a blade if necessary and fill in all the nicks and scratches. Subtle changes to a blade's pitch have to be made through a process of heating, bending, cooling, and reheating; particularly difficult blades can take two days to

straighten out. Once the welding and repitching are complete, Ciccariello and Gonzalez ("an ace grinder," Weaver says) smooth out the surfaces of the blades. Like every step in the process, this is a tricky activity—they don't want to grind out too much and make one blade lighter than the others, but they can't leave any imperfections, either. Ciccariello, who ran a body shop before working for O & M, is an expert, but he says that it takes at least six months to become even a half-decent grinder. He's lost count of the young apprentices he attempted to train who were either unwilling or unable to master the art.

Finally, the wheel is hoisted onto Overbye's balance to ensure that all the blades are equally weighted. Ciccariello points to a 2,000-pound wheel already set up and amazingly spins it with only a slight motion of his hand. The wheel turns lazily and stops with the blades aligned equally to either side. If one blade had been heavier than the other, it would have pulled slightly to that side, providing an instant visual cue. When this happens Ciccariello has a simple system of clamps that he adds to the opposite blade to calculate its excess weight. "I have them all marked out: a pound and a quarter, 13.3 ounces, 2 ounces. I can work it out exactly." This particular set took all three men four days to complete—about average for a job this size, Ciccariello says.

Tugboats—the bread-and-butter of O & M's work—operate on tight schedules, working twenty-four hours a day, 365 days a year if possible. The amount of time they spend in dry dock needs to be kept to an absolute minimum. To this end, like cars, most of them have "spares," an additional pair of wheels that O & M will store in its yard if the owners are regular customers. Before a boat comes in for a wheel change, which the Coast Guard mandates tugboats must do twice every five years, the owners generally notify Weaver of their needs. He ensures that their spare wheels have been reconditioned and sends them down to the dry dock as soon as possible. Ciccariello makes the deliveries, a pair of beautiful shining wheels strapped to the back of his truck like works of art destined for a museum.

O & M gets repeat business from the same customers—consisting largely of New York's main tugboat operators, such as Buchanan and Moran—so the

company doesn't have to worry too much about advertising or promotions. Nevertheless, Ciccariello says, "This kind of business, you're only as good as your last job. You can do something right a hundred times and something wrong once, and it's that one time they'll remember you for." Competition is limited; though there is another repair company on Staten Island's north shore, Ciccariello says that the two businesses keep pretty much to themselves. "He has his customers, we have ours. We don't step on each other's toes, you know?"

Despite the steady flow of business, O & M's future is far from certain. Weaver goes so far as to call his enterprise "a dying art." There's a dearth of young people interested in taking up the profession, he says, and a family dynasty is not in the cards: His stepson works for the Bloomberg Company, and his son is an expeditor for Wal-Mart. "My son comes down once in a while to putt around," says Weaver with a smile. He doesn't seem overly disturbed. He enjoys his work and takes pride in it, and besides, he has hobbies to attend to.

Gracing the interior of O & M's cramped office, with its stale smell of cigarettes and a Snap-on Tools clock that bears a bikini-clad woman on the face, is a picture of a bright green car, a 1941 Studebaker that Weaver restored from scratch. "Corvette front end, Trans Am rear," he says. He mostly stores it in the garage now, where he has a potbellied stove and hangs out to "keep away from everyone I don't want to see." In the past he has taken the Studebaker to shows and even raced with Ciccariello, who is also a car enthusiast and used to own a "totally done-up" 1972 Vega that could go from 0 to 140 miles per hour over a quarter mile. "I wasn't that good, though," Ciccariello admits, "and it cost about $500 a weekend—and that was without breaking anything." What he really wants now is a 1967 Chevelle. Weaver smiles indulgently. It's obvious that for both men, the appeal of using their hands, of restoring something old and beautiful, is deeply ingrained and unlikely to fade soon.

MARK RUDES

Fish Wholesaler

A procession of trucks rumbles through the deserted streets, slowly growing in number. The night air is as dark as the megawattage of the city ever allows—a dirty gray leached of all definition, creating the impression of being in a fog. Metal fencing, shuttered garages, and car-crushing plants line the way; ahead, a crane's giant maw stands frozen, poised above a pyramid of crumpled doors and hoods. PLAYERS CLUB reads a sign in curlicue yellow script above a building with its windows blacked out; another says WE BUY PALETTES. This is the Hunts Point neighborhood of the Bronx at 3:30 A.M., and the trucks, belonging mostly to retail vendors and restaurant buyers (deliveries have already been made by this hour), are becoming a bona fide convoy. They head toward Hunts Point Market, the city's vast wholesale food market spread over sixty acres on a spit of land where the Bronx and East Rivers meet.

Finally, the convoy turns and passes through a row of security booths before pulling up next to a long, pink shed. A few yards away, the East River glints sullenly in the parking lot lights; the outline of Rikers Island Penitentiary can be made out on the other side. All vestiges of this nocturnal world are instantly dispelled inside the shed. The brightness of a thousand Halophane lights assaults the senses, as does the boom of men's voices reverberating off the concrete floor and rising into the steel latticework above. Except for the insistent *beep-beep* warning of forklift trucks whizzing along the central corridor, one might be in a massive gymkhana. This anodyne environment, four football fields in length and chilled to a steady forty-one degrees, is the New Fulton Fish Market at Hunts Point, home to about thirty wholesalers who on November 14, 2005, made the move from the market's historic former home in Lower

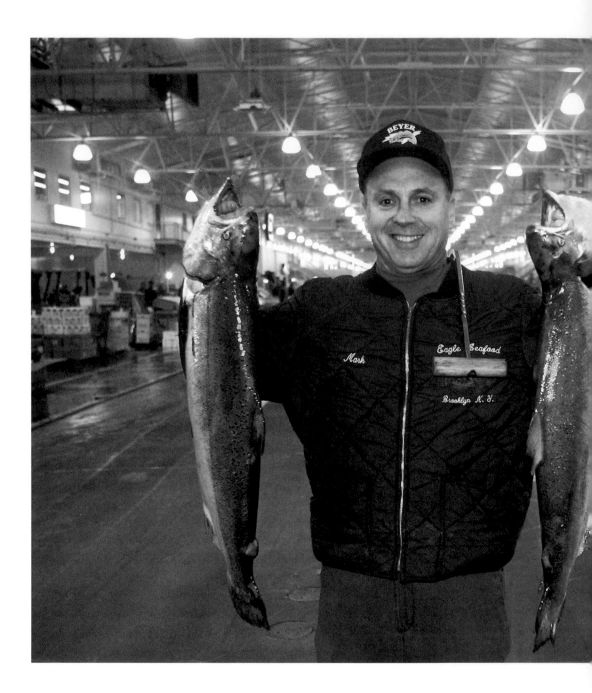

The brightness of a thousand Halophane lights assaults the senses, as does the boom of men's voices reverberating off the concrete floor and rising into the steel latticework above.

Manhattan, where it had been since 1822. There is barely an odor of fish, but the smell of newness is everywhere.

A slender man in his fifties with a faintly amused expression on his face is walking among the boxes of fish piled high on either side, carefully examining their contents. Using a small hook, he lifts a specimen to his nose, deftly catching it beneath the gills. "Rickie, I need a bunch of Brazils. These are twos and fours, right?" Rickie confirms that this is the case, and his inquisitor nods. "Send me ten, all right? I'll let Freddie pick 'em out." His manner is brisk, authoritative, and polite; this is a man completely in his element.

Mark Rudes has been in the fish wholesale business since 1974 (and his father for forty years before him); there is little he does not know about fish. "Brazils," it turns out, are Brazilian red snappers; the numbers refer to their weight in pounds, and Rudes has just purchased ten cases, or about 400 pounds, for his son's restaurant supply business in Brooklyn. Rudes's own company— Beyer Lightning Fish, which sells about eight to ten tons of fish a day and turns over around $20 million annually—is temporarily out of snappers that size, so he has had to avail himself of the wholesaler next to him. Having taken care of this transaction, Rudes proceeds to point out the array of species all around, his salesman's hook slung casually over one shoulder.

"That's red mullet, also known as rouget, which was flown in this morning. And you've got gunard, this comes from Brazil. We've got parrot fish—those are reef fish from Brazil. This here is New Zealand king salmon, the finest eating salmon in the world. . . ." Lying on their beds of ice, the fish stare blankly upward, mouths open, as though in protest. Some, such as a cadaver-gray monkfish, an array of razor sharp teeth set in a rictus, threaten to bite any hand that comes near. With the exception of some delicate green sea urchins in wooden punnets, all the fish are in polystyrene cases—wooden crates, along with the days of working outside on a cobblestoned street, are over. The fish are transported by air in these cases, lined with gel packs rather than ice because, as Rudes explains with a grin, "ice might leak into the belly of the plane, and then you'd get about a $10,000 bill for steam cleaning, and you don't want that."

Rudes is more than just an expert on fish; he is also an expert on the Hunts Point Market itself, having been largely responsible for its design. As a young man he obtained a bachelor's degree in science and architectural technology before joining his father's company. Unable to come up with a workable design for the awkward little sliver of land provided by the city, the market architects finally called upon him. "I said, 'Don't worry. I'll have a full set of detailed drawings for you by Monday,'" he recalls brightly. "So I went home, got on the computer, and sent them the specs, and with a couple of minor changes, that's the way it turned out." In fact, the process took somewhat longer

Rudes is more than just an expert on fish; he is also an expert on the Hunts Point Market itself, having been largely responsible for its design.

than that, as Rudes admits a moment later, with eight different versions of the plan finally being coerced into a functional market. But with his unique combination of architectural and wholesaling knowledge, Rudes can justly claim the lion's share of the credit for the plan eventually adopted.

Not surprisingly, he is gung ho about the Hunts Point location. "I'll tell you this. I didn't want to come—most of the guys didn't want to come—but I don't even *think* about the old place anymore. I can't believe I did business there for thirty-one years outside in the snow and the rain in a space 120 feet long by 16 feet wide."

Rudes is not alone in this sentiment; without exception, his fellow wholesalers, men unlikely to withhold their true feelings, have nothing but good things to say about their new environment—"state of the art" being the almost universal mantra expressed around the market's giant confines.

The majority of the fish sold at Hunts Point arrives at JFK airport by early evening, a few hours before it's sold (a small percentage, mostly local East Coast fish, arrives directly by truck). Each wholesaler has his own refrigerated trucking service standing by to collect. Some, including Rudes, also have their own customs agent to ensure the smooth expedition of goods. This is necessary in part because of the enormous amount of paperwork involved: There are strict Food and Drug Administration health protocols to follow, and each shipment must be matched to its country of origin to guarantee that the species therein is federally approved and falls within the seasonal quotas set for it. Security also has become ever more of an issue since September 11, 2001; Rudes points out a yellow tag on a case nearby, a sign that it has been subject to a spot-check in customs. "Once in a while they'll even run a whole palette through an X-ray machine," he says. These and other new procedures have doubled his shipping costs, from around $100 per shipment to nearly $200. "People think we make a lot of money, but it's a very small profit margin. The joke in the business is, 'Lose money on every sale, make it up in volume.'" He laughs dryly.

> *"People think we make a lot of money, but it's a very small profit margin. The joke in the business is, 'Lose money on every sale, make it up in volume.'"*

Once the fish arrive at the market, they're unloaded in a temperature-controlled bay that can accommodate up to twenty tractor-trailers at once. "Hi-lows," as the electric forklifts are known, can zip straight into a truck and out in minutes. By 3:30 A.M. virtually every delivery truck has been unloaded and is gone. The old market, by comparison, had room for only four trucks at a time,

and its uneven cobblestoned floor made the hi-lows inoperable, requiring a time-consuming process of unloading in stages by handcart. Hygiene is also superior here, Rudes attests. At the end of every working day (around noon), the entire market is hosed down by a specially designed "vacuuming-squeegee machine," the display tables are tipped on end and sanitized, and the walls are washed down. "There's no excuse for a facility like this to be dirty," Rudes says. "We can't say, 'Well, it's been around for 200 years.' If we find a piece of dirt on the floor, we put it there."

Each company that works at Hunts Point is part of a cooperative (as are their counterparts at the nearby produce and meat markets), and each pays a portion of the costs for items such as refrigeration and sanitation relative to the amount of space it occupies. To some extent, each company also operates within itself as a mini-cooperative. Rudes's enterprise is typical in that, while he is the owner, the fifteen or so employees who work for him are paid on commission and each works fairly independently, with the power to deal directly with suppliers and customers and set their own prices. With about 200 species of fish and shellfish available at any one time (and 1,500 on the books), it simply wouldn't be practical for Rudes to control everything.

There is an obvious camaraderie among Beyer Lightning employees—indeed, to the whole market, which rings with the sound of black, white, and Asian men happily and exaggeratedly calling to each other, as though intoxicated by this mythical place they inhabit. (The market has become infinitely more multicultural, though not less male-dominated, since the days when a young Rudes started.) Bobby Patzer, a mustachioed ex-Marine, takes care of the tuna for Rudes, slicing their beautiful blue-gray trunks into four neat fillets with a couple of movements of an enormous knife; Rudes watches him admiringly, as though for the first time. "I've known Bobby for ages," he says. "I'd trust him with my life." Nearby, Joey and Tom "the Ghost," two other Beyer Lightning employees, joke amid their constant activities.

Rudes is typical of many of the wholesalers here in that he came into the business via his father. Herb Rudes, whom he describes as "a tough old bird,"

founded the Lightning Fish Company in 1929, later amalgamating it with a partner, Loui Beyer, to form Beyer Lightning. (The old blue enamel sign for the company hung for years above their stand on Fulton Street. On the last day of the old market, Rudes got up on a forklift, tears in his eyes, to take it down; rehanging it above his new office was the first thing he did upon arriving in the Bronx.) As children, Rudes and his brother were encouraged to work at the market during the summer holidays. Despite warnings from their mother—"If you don't do good in school, this is where you're going to end up"—they loved the place, though Rudes had no plans to join the family business.

The harsh economics of being an architect, however, made him change his mind ("When you're in your senior year and your check's already cleared, they give you the bad news: You earn *nothing*," he laughs). On his first day at Beyer Lightning, he asked his father what he should do. "That's easy," his father replied. "Grab a broom. What else do you know?" An exponent of the tough-love school of parenting, Herb Rudes made his son learn everything from the bottom up, from how to deal with suppliers to how to cut and prepare every type of fish, essential preparation for eventually taking over the business. It is clear how much affection Rudes holds for his father and how gratified he is that his own son, Michael, has chosen to carry on the family tradition. "I gave him the same speech my father gave me," Rudes says: "'When you get out of college, you've got five years to find something you like or can make a living at, and if you can't, come into the business with me.' About three and a half years later, we're having dinner one night and he says, 'Dad, do I have to wait the whole five years?'" Rudes's face lights up at the memory.

Despite the relative ease of the new conditions in the Bronx, being a market wholesaler is not easy. First, the job requires an unflagging energy, a typically New York vigor that Rudes and the other vendors emanate like a force field. This is necessary not only to overcome the thousand and one bureaucratic and practical hurdles that stand in the way of such a highly regulated business, but also to persuade the public to *buy*. The New Fulton Market is, as Rudes points out, wide open: "There's thirty-odd vendors selling basically the same thing.

Customers can walk up and down, inspect the quality, check the price, and come back and bargain. If you don't have the right price or product, they're going to go somewhere else."

Then there are the hours. Rudes works a fourteen- or fifteen-hour day five days a week, rising at about 10:00 P.M. and heading straight to the Bronx from his home in Jericho, Long Island. By 9:30 A.M. most of his salesmen are done, though Rudes lingers until at least midday or 1:00 P.M. to take care of paperwork. Even after all this, he is rarely tired. "I'm an active guy. I don't go to sleep. I have a million hobbies," he says. These include collecting and restoring antique cars, building model train sets, and working on a history of the old market (he has an agent and a ghostwriter for the latter). There are, however, two things that Rudes does not do: go fishing or eat fish. "I'm more of a pasta guy," he says, evincing his first sign of embarrassment. "But my wife likes fish. Whenever we go out, she'll order salmon or the fish of the day. But me, I'll have the pasta."

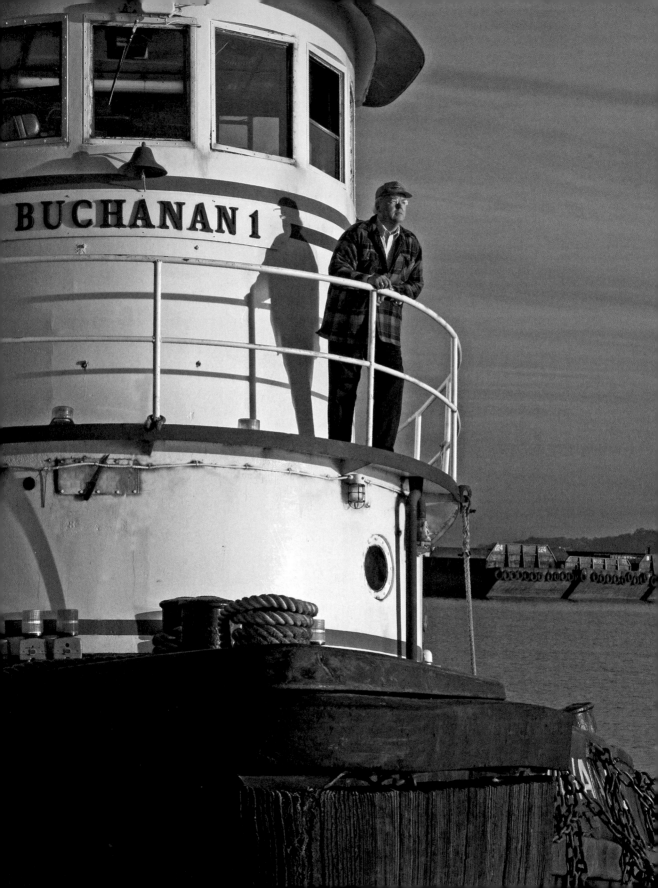

OWEN MORIARTY

Tugboat Captain

The Allman Brothers are playing through the wheelhouse stereo, their churning guitars a suitable accompaniment to the deep throb of the 2,200-horsepower engines below. It's 6:30 on a Monday morning, and the sun is rising over Hempstead Harbor on the North Shore of Long Island, glinting off the water's surface and turning the steel scows moored in the distance a deep, rusty gold. Men's voices rise up from the floating dock that the tugboat *Buchanan 1* is tied to, and the occasional mad revving of *Dory Barker* and *Mister T*, two other Buchanan Marine tugs moored alongside, sends fumes of black diesel smoke shooting out of their stacks.

It's "shifting time," when the crews of the company's various tugs at this staging point outside Port Washington switch over for the week. A few minutes earlier, a weary six-man crew had stepped off *Buchanan 1*, passing control to its new master, Captain Owen Moriarty. As he was leaving, one of the men gestured and shouted at Moriarty, "We caught two beautiful fish this morning!" Moriarty laughed indulgently and waved back. Two years past standard retirement age, he is Buchanan's oldest and most experienced captain and probably the oldest captain still working in the New York area.

While it was still dark that morning, Moriarty had left behind the comfort of his house in Rockaway, Queens, and his wife of forty years, Kathleen, and headed out on the Long Island Expressway, bound for yet another week of twelve-hour-on/twelve-hour-off shifts. He's been following this life since he first became a captain in 1966, at age twenty-eight. The reason for such longevity is simple: "Once you get the water in your blood, it's hard to give up," he says. "I like coming to work. It's still stimulating, you know? I've worked

all my life. I'd die if I retired. A friend of mine went down to Florida and"—he blows out his cheeks—"*pheeewww*. Gone."

His accent is a thick Irish brogue, without any American tinge; only the crisp pacing of his speech gives any hint of his forty-odd years of living in New York City. The only son in a family of six children, Moriarty was forced to leave school in Killarney, County Kerry, at age sixteen, after his father died. He went to London to look for work. His first job, which he still recalls fondly, was mopping floors at a Lyons Tea House near Marble Arch. "They had an orchestra there, you know, a twenty-seven-piece orchestra right there in the middle of it! They played all the classics and everything." After Lyons

Moriarty has led a captain's life since 1966. He says the reason for such longevity is simple: "Once you get the water in your blood, it's hard to give up."

came a brief stint as a bus driver for London Transport (he drove the No. 16 bus down Edgeware Road). Then Moriarty moved to Brooklyn and took a stab at working on Wall Street, something he instantly realized would "kill" him if he stayed. He decided to enter the maritime world; after breaking in as a deckhand for three years, he took his mate's license, and a year later he made captain. At the time, he was one of the youngest captains in the harbor, something he is characteristically modest about. "Well, it's supply and demand. I was just lucky that there were openings then," he says.

The company that Moriarty began working for, the Bronx Towing Line, was later taken over by Buchanan Marine (which in turn is now owned by Oldcastle Materials, a giant provider of aggregates and cement for construc-

tion). Buchanan Marine operates more than 200 scows that transport traprock, aggregate, and other products along the East Coast and has its own fleet of tugs to tow the scows. The company maintains coastal staging posts from Virginia to Connecticut; the quarried material is delivered straight to them. Directly behind *Buchanan 1* stands a vast pyramid of stone that a crane is greedily digging into, and nearby is a row of already filled scows, their tops neatly "raked off" to create an even load. A line of seagulls perches on top, staring down as though with interest in all this human endeavor.

It is Moriarty's job to ensure that "light" or empty scows are delivered on time for filling and then taken for delivery—usually down the Hudson River or along the Long Island Sound, though until they arrive for work each week, the crews have no idea exactly where they will go. A typical weeklong shift might involve several round-trips from Port Washington to Pine Orchard, Connecticut, or Haverstraw, New York, with a number of stops along the way, including Flushing Bay, various urban waterways such as the Gowanus Canal and Newtown Creek in Brooklyn, and the Kill Van Kull and Arthur Kill along Staten Island.

Inside, *Buchanan 1* resembles more of a fraternity house than a place in which an older man might be comfortable. First, there is the noise: The crew operates twenty-four hours a day, with at least three men on duty at any given time, and the engines never stop; their constant vibrations—annoying and soothing in turn—are the aural backdrop to life on a tug. Then there is the space, or rather lack of it. The galley is barely 8 feet wide, a tight squeeze for a large man like Moriarty, who is 6-foot-4 and whose head almost brushes the ceiling. The galley contains a microwave, a small stove with electric hot plates, and a television and VCR on a bracket in the corner. Tacked to the wall is an old Maxwell House coffee can with a sign above it that says EAR PLUGS, and above the sink is another sign:

YOU USE THEM

YOU WASH THEM

YOU PUT THEM AWAY

CLEAN THE GALLEY

The company provides a $700 weekly allowance for food for the crew, and every Monday one of the deckhands goes to the local Stop & Shop. Eric Chase, the designated shopper today, has already half-unpacked a mound of plastic bags; lying on the table are bags of Lay's potato chips and English muffins, boxes of cereal, cartons of milk, and cases of water and Coca-Cola. Each crew used to have a designated cook as seventh man, but due to new limitations, the six workers now take turns cooking. Surprisingly, Moriarty says they've all gotten pretty good at it. "We have scampi, beef Wellington—there's a real gourmet cook on board at the moment. In fact, it causes trouble at home: *'That's not the way to do it!'*" He laughs. Off the galley are two miniscule bedrooms with bunk beds for the crew; a Penthouse Pet is pasted to the wall in one of them, an electric guitar between her breasts. Moriarty and his mate have a slightly larger but no more distinguished room above, with a big television gaffer-taped to the table between the beds, a reminder of how rollicking life in a tug can be out on the open waves.

As such a confined space suggests, the hardest part of being part of a crew is the unrelieved proximity of one's peers. "An old man told me one time, 'You don't have to be able to steer a boat at all; you've got to be a *psychiatrist* to do this job.' And it's true," Moriarty says. "The worst thing that ever happened to our industry was the damn cell phone, because in the old days you weren't able to get bad news. Now, if a girlfriend isn't home when they call, oh, God, they come to me: 'It's 11:00 at night. *Where is she?*'"

Moriarty is clearly a good psychiatrist, having kept the same crew for nearly six years now. "I'm old school," he says of his professional demeanor. "Walk softly but carry a big stick, you know?" Yet while there is clearly more than a hint of steel in his watchful blue eyes and decisive manner, Moriarty is also a generous boss, allowing his crew to sleep late if they have worked particularly hard and openly appreciating their efforts. "They give me 180 percent, these guys," he says. Like being a soldier, working on a tug consists of long periods of watchful inactivity interspersed with occasional bursts of real pressure. Towing tens of thousands of tons of cargo in busy shipping lanes (the largest

scow can hold 2,000 tons of cargo, and the largest tug can tow up to sixteen scows)—plus navigating sharp turns in the Hudson or waves 5 or 6 feet high in the Sound—is not easy and takes judgment. If the weather is particularly bad, scows can flip over, losing their valuable load; complicated and time-consuming maneuvers are necessary to flip them back again while towing the rest of the cargo to safety.

Tugboats are also innately dangerous places—20,000 gallons of diesel fuel sitting amid two powerful, churning engines. Moriarty's longtime engineer, Steve Basle, was once badly burned on another vessel when the crankcase exploded, sending a piston flying through the side of the engine wall and starting a serious fire. Moriarty recalls that Basle was "all burned like the Elephant Man, third-degree burns everywhere.

Tugboats are innately dangerous places—20,000 gallons of diesel fuel sitting amid two powerful, churning engines.

The only thing that saved him was jumping into the water—and even then, when he came up he was still burning." Such stories provide a counterpoint to the air of faintly amusing domesticity suggested by *Buchanan 1*'s galley, bunk beds, and shopping bags.

Not surprisingly, after a week on board, Moriarty looks forward to going home. Kathleen is the model of the attentive wife, bringing him a folding table for his coffee and another one for his ashtray. "Every Monday is a honeymoon when I come home, and every Friday I can't get hold of a divorce lawyer," he proclaims contentedly, stretching his legs out in his favorite chair. A radio plays in the background, an echo of the wheelhouse in which Moriarty spends so much of his life. The sitting room is dark and neat, with pictures of the Moriartys' four children on the wall. Their youngest son, Brian, has Down syndrome

and lives at home with them; another son, Sean, works at Buchanan Marine, though not as a captain. At one point Moriarty's daughter-in-law stops by with her five-year-old, Kevin, and Kevin and Brian come and go, laughing. There is a relaxed, familiar feel to the home, reinforced by a sign outside that says *TA FAILTE ROMHAT,* Gaelic for "You are welcome."

"It's not a bad life," Moriarty admits. "I'm off for a week; I can do a lot of things. We travel—we went to Cancun, we go to England at least once a year." Moriarty has four sisters who live in England and another who is a teacher in San Francisco and used to be a nun. He still loves Ireland and says he would be happy to live there one day, except that it's so expensive now. "When I was growing up, there was nothing there," he says. "Otherwise I would have stayed." He would also

> *"Every Monday is a honeymoon when I come home, and every Friday I can't get hold of a divorce lawyer."*

like to take a cruise, but Kathleen "hates the water" and is terrified of boats. He himself—"a real scoop!"—can't swim, never having had time to learn as a child, a source of infinite amusement to his crew.

On the subject of the future of maritime transportation, Moriarty is less cheery. The economics of the industry require that "more and more is done with less." This means building bigger tugs and scows than ever before and manning them with fewer crew. "In the past we had four deckhands, two engineers, an oiler, a cook, a captain, and a mate. Now we do the same amount of work with six men, and probably they'll cut down the engineer soon to what they call a 'deckineer.' He might get 30 cents an hour more to take care of his

engine, but that's what I see happening. Some of the tugs already have it in the harbor." (Buchanan Marine is a union company; nonunion tugboat companies, such as McAllister Towing, already operate with crews of four people or fewer.) In this respect, the towing industry is simply following the trends already established in the rest of the shipping industry by container ships and oil tankers, a necessary development if water is to continue to compete with rail and roads.

Although things are undoubtedly harder now for a young man trying to break into the industry than they were in the giddy 1960s, some things remain the same. Moriarty is currently training a young Irish deckhand named Sean Golden for the wheelhouse. Like his boss, Golden came to the business after he found a brief spell on Wall Street lacking. "This kid has potential," Moriarty says. "He's one of the best I've had in a long while. And I have the patience to teach him—after all, somebody had to teach me."

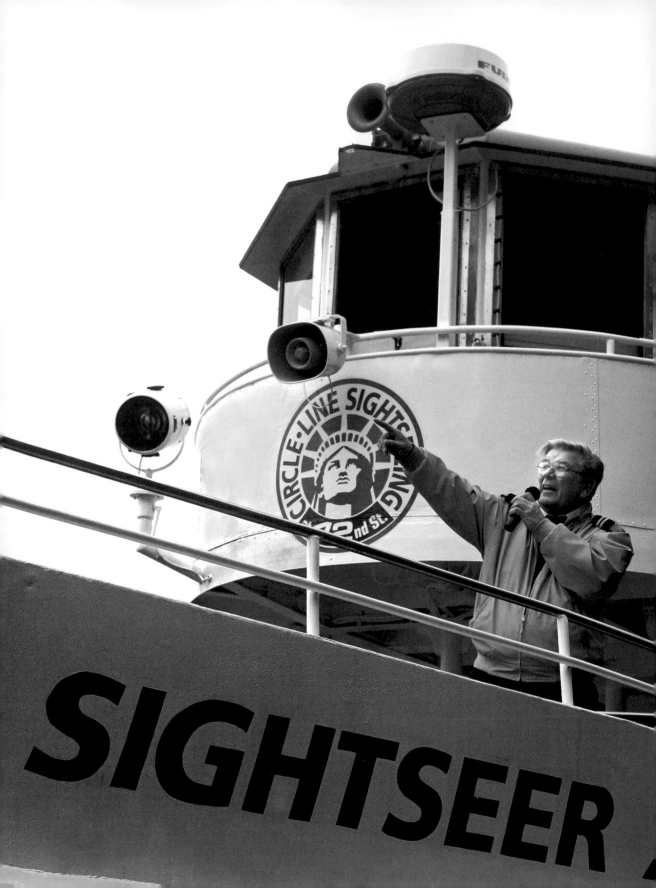

JOHN MASON

Circle Line Tour Guide

The crowd lining up outside the Circle Line gates at Pier 83 on the Hudson River has the vaguely absentminded air of all tourists, wrenched from the purposefulness of their normal daily lives. Clad in baseball hats, sunglasses, sweatshirts, and iPods, they are a polyglot group, chattering in French, German, Italian, and British-accented English. Young children tug on their parents' arms, eager to rush onto the waiting boat, and a wail comes from inside a stroller pushed by a woman wearing a rubber Statue of Liberty crown. Greeting them are Ed Weber, who, as Circle Line's longest-serving captain, has been circumnavigating Manhattan since 1961, and John Mason, the company's longest-serving tour guide, who started just a year after Weber. Down in the engine room is another "lifer," Jack Barry, who has worked since 1955 as an engineer on Circle Line boats. Although they don't realize it, the boarding passengers are in the hands of 137 years of collective experience—or, as Mason puts it, "They've got Drip, Dribble, and Drool today."

Like most of Circle Line's eleven tour guides, Mason has an acting background, having studied at the American Academy of Dramatic Arts after leaving high school in Brooklyn. In 1956 he was drafted into the U.S. Army, where he continued to act, starring in theatrical versions of *Stalag 17* and *The Caine Mutiny* and performing in a traveling stand-up comedy routine with a partner (they won second prize in an all-Army competition). Despite his strong nautical background—his father was a tugboat captain, and the rest of the men in his family were either captains or pilots around New York Harbor—Mason initially showed no desire to enter the maritime world. He enjoyed working as a deck-

hand for his father during summer holidays, but the stage came first: "I wanted to act; that's what I wanted to do," he says.

Returning to New York in 1957 after being discharged, Mason attempted to pursue an acting career but found it difficult. For a while he became a partner in a trucking company, something he "really had no interest in at all," although indirectly it led him to Circle Line. "I used to stop in one of the trucks on the West Side and have lunch there, and I'd see the boats and hear the tour guides giving their opening remarks before they sailed, and I said, 'That would be a nice job.'" Mason eventually interviewed and was offered a full-time position; after breaking in with another tour guide for two weeks, he was on his own.

Mason loves what he does—"They'll have to carry me out of here," he says when asked if he would ever leave—but in his dry, laconic delivery there is perhaps a trace of regret at the career he might have had had he not stayed with Circle Line. Whereas the other tour guides are bright and snappy, Mason is a master of the understated; hearing him in action, one is reminded of an old Catskills trouper making the best of things in the face of adversity, and the *badda-bing* drumroll after one of his deadpan punch lines is almost audible. (As his boat slides past the city's tow-pound at Pier 76, he says, "That's where they tow you if you're parked illegally. If you don't pay up within twenty-four hours, they push your car into the Hudson." Pause. "No, of course they don't do that." Pause. "They stopped doing that three weeks ago.")

In his years of circling Manhattan, Mason has seen the waterfront change almost beyond recognition. The piers that once ringed it have mostly been torn down, and the barren edge that followed such destruction has itself been transformed into a belt of walkways and parks in many places. He has seen the industrial edge of Jersey City mushroom into a contender with its glamorous sister across the water, and most dramatically, the Twin Towers both rise and fall. Mason and his son, Chris, who also works for Circle Line, were the only two guides allowed to give tours around the Lower Harbor in the weeks following September 11, a period that "really tore me apart," Mason says.

But even bigger changes have occurred in the tour population itself. "When

I started out, most of our tourists were Americans, from the Midwest primarily," Mason says. "The business was owned by five Irishmen, and they did an amazing job at operating it. They'd bus them in from everywhere. Then it started to change, and we began carrying more Europeans and then Asians, and people wanted us to start speaking in their language, which was a bit of a problem." A more insidious problem was that people of all nationalities began losing their ability to sit still and concentrate. "You could hear a pin drop," Mason says of his earlier days as a guide. "Everyone was paying attention. They wanted to be instructed." Now, after the first hour, even the best, most attentive audiences start to chatter and lose interest. Like the other tour guides, Mason has learned to adjust. "I used to talk to the audience all the time, telling them things, asking them, 'What's your name? Where are you from?'— stuff like that. But three hours is a long trip, and

In his years of circling Manhattan, Mason has seen the waterfront change almost beyond recognition.

now I just let them cool it on the Harlem River and coming back down the Hudson." He seems comfortable with this change and says that, in many ways, the tours are better now that he's cut out all the "hokey Disney stuff."

As *Sightseer XII* draws level with the financial district, Mason, who has been sitting cross-legged at the rear of the upper deck, stands and holds his microphone stiffly under his chin, like an after-dinner speaker about to give a toast. "On your left," he says in a somber voice, "is the former site of the World Trade Center. Sixteen acres of destruction." He lets the phrase hang in the air for a moment, and the crowd rushes as one to the side of the boat to snap pictures with their cameras and cell phones. As they soak it up, Mason provides suitably horrific details of what occurred that day. A few minutes later, as the vessel rounds the tip of Lower Manhattan, he subtly shifts the mood. "The

office buildings here have been used for many films you may be familiar with. *Men in Black* and *Working Girl* were both shot here, and Al Pacino in *Devil's Advocate* had his office in that shiny glass building. It was on the thirteenth floor, you may recall. . . ." All the heads turn happily again.

Mason is the first to admit that his job is tiring. "Some people think that it's easy—you just sit here and talk—but it's a *job*," he says. "Every crowd is different, and you have to gauge what it is and try to keep them in the palm of your hand." Sometimes, if he has a really responsive crowd, he'll stand in front of it, making his presence clear; other times he prefers to wander around and remain more discrete, quietly observing the group. Aside from a few guaranteed favorites—Ground Zero, the Statue of Liberty, Yankee Stadium—it's hard to know what will captivate the audience's interest. Mason changes his material accordingly. Celebrities and the price of real estate are always popular, so he reads the papers daily to keep up with such matters.

But Mason is also a self-confessed "infrastructure buff" and can't resist talking about such prosaic structures as the Holland and Lincoln Tunnel ventilating towers, the North River sewage plant, and the old High Bridge aqueduct across the Harlem River. ("Ah, John, stop. You're killing us with this stuff," he says to himself after each digression.) He keeps a small library of books on the city in his neat brownstone home in Bay Ridge, Brooklyn, including a well-thumbed copy of the *Encyclopedia of New York City,* inscribed by former mayor Rudy Giuliani to "The Prince of Guides," the sobriquet Mason has acquired at Circle Line over the years. A recent book on the city's entrails, *The Works: Anatomy of a City,* is marked carefully at the entry for the Lincoln Tunnel.

Given this predilection, it's ironic that one of the most interesting parts of the 35-mile tour for Mason, the bridge-laden stretch between the Triborough and Henry Hudson Bridges, is where he gives his audiences a breather, allowing them to indulge in snacking, smooching, or simply staring into space. Even here there are occasional resurgences of energy—a scrum as the sacred halo of Yankee Stadium slides into view on the right, a lesser nod of curiosity at the huge blue *C* painted on the cliffs opposite Columbia University's playing fields ("It stands for

Circle Line," jokes Mason). He barely has time to point out the creek where Henry Hudson moored *Half Moon* in 1609; moments later *Sightseer XII* rounds the bend and is heading back down the Hudson, the Palisades blazing to its right.

As the West Side skyline rises against Central Park, Mason knows what he must do. "That's the San Remo," he says, pointing out the building's famous twin towers. "A lot of celebrities live there: Diane Keaton. Dustin Hoffman. Donald Sutherland. Raquel Welch. Barry Manilow. Bruce Willis. Steve Martin. Steven Spielberg." Pause. "And they all share a one-room apartment." The audience laughs, happy with the joke and happy that the end of this long ride is in sight. A woman comes up to Mason and asks in a thick Southern accent how much real estate costs in Manhattan, "per square foot, I mean." Mason assures her that a 2,000-square-foot apartment in Tribeca will set her back about $5 million, around $2,500 a square foot. She seems satisfied with the information and nods her head vigorously. A young British man nearby adds, "It's a bit like Blackpool, isn't it?"

As Pier 83 looms into view again, Mason offers transportation details. The boat's engines rev furiously as it edges into its berth; the air is filled with the smell of diesel. Already, at 4:00 P.M., the West Side Highway is beginning to clog up with homeward-bound vehicles, the traffic lights changing in unison as far as the eye can see. Captain Weber joins Mason at the bow, and together they stand and thank the departing passengers like airplane stewards: "Thanks for coming." "Watch your step." "Enjoy your visit." Mason seems tired but not unsatisfied, as do the departing passengers, some of whom politely express gratitude on their way out.

After such a tour, it's easier to understand the fulfillment that compensates Mason and his fellow crew members for their long years of duty. For in its rag-bag compendium of history, engineering, tragedy, celebrity, natural and man-made beauty—and not least its taxing duration—this ultimately "touristy" activity manages to capture something of the essence of this mongrel city in a way that a visit to the Met, or even a walk in Central Park, cannot. Mason surely knows this; it is what transforms his four-plus decades of unflashy service into something approaching a labor of love.

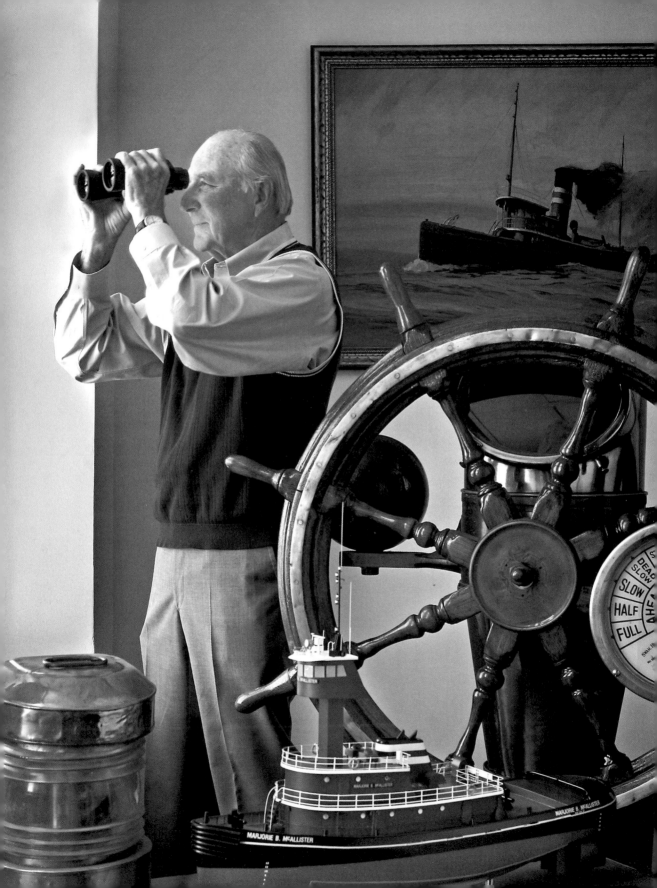

BRIAN A. McALLISTER

Tugboat Company President

The story of McAllister Towing, now in its fifth generation and one of the old-est family-owned marine towing companies in the United States, is the stuff that television miniseries are made of. It contains struggle and hardship, great success and sudden failure, boardroom skullduggery and courtroom battles, and, above all, the constant backdrop of New York Harbor—an integral part of the dynasty since the first McAllister, James, arrived here in 1864 from a small coastal village in Northern Ireland. He set up business with a single sail lighter, moving his family into Manhattan's infamous Five Points slum.

Captain Brian A. McAllister, James's great-grandson and the company's cur-rent patriarch and president, has an office high up on Battery Place, near Man-hattan's tip. Surrounded by the same sweep of blue-gray water that was intimately familiar to his ancestor, McAllister runs what is now a $150-million-a-year business with seventy-five tugboats operating from Maine to Puerto Rico. Directly behind him, the modern curves of the Verrazano Bridge punctuate the horizon; over his right shoulder a Staten Island ferry trudges wearily southward, and to his left a group of yachts form a cluster of white triangles against the Jer-sey shoreline. Occasionally a vessel catches McAllister's attention, and he picks up a pair of binoculars sitting on his desk and peers through them. "That's one of ours," he says with satisfaction, of a tug pushing a barge down the Hudson.

McAllister, who has the lean physique and considered manner of a college professor (he says "Jeez" sometimes, but that is the strongest his language amounts to), started his first official job for the family on a tugboat at age fif-teen, in 1947. Before that he'd had a good deal of experience riding tugs during World War II and remembers seeing ships assembling for convoys in the harbor.

The war was a good time for the family business, which had suffered badly during the Great Depression and nearly gone under. "The '30s were a time of collapse for this industry," McAllister says. "They passed the Smoot-Hawley Act"—a notorious 1930 trade protectionist law that raised the tariff on foreign goods by as much as 70 percent—"and it just dried everything up." For McAllister Towing and other major tugboat operators in New York, virtually the entire business of hauling cargo from foreign ships ceased overnight. "We were down to three tugboats," McAllister says. "They needed repairs, but no dry dock would let them in because we didn't have any money, and only one tugboat could run. All of our

The story of McAllister Towing contains the stuff that television miniseries are made of: struggle and hardship, great success and sudden failure, boardroom skullduggery and courtroom battles.

barges were wooden, and the caulking started to go, and they ended up sunk all over the harbor." McAllister's grandfather, Jim, issued the first of several dire warnings to younger generations of the family: "We're in a business that's going under, and you can't stop it."

In fact, the company did survive. Although McAllister's father, Anthony, was forced to leave the company to run a dry dock in Brooklyn, an uncle continued the family tugboat business. By snapping up bargain-price vessels from other failing companies and "patching them up with putty and bailing wire," he managed to emerge from the war with a large, if motley, fleet of thirty-five tugboats. After the war the family continued to buy smaller companies, including

the Russell Towing Company, with its fleet of ten tugs and a dozen oil barges, and the Dalzell Towing Company, one of the oldest such enterprises in the nation. The whole industry was in a process of rapid consolidation, and a few big fish were swallowing up the "Irish Navy," as the predominantly Irish-owned East Coast towing companies were informally known. Eventually, one of the biggest fish was McAllister Towing.

As a teenager Brian McAllister—by his own admission "not much of a scholar"—had no particular interest in the family business or in attending college, being more concerned with his principal passion: basketball. His father eventually enticed him to attend SUNY Maritime College in the Bronx, pointing out, as McAllister says now, "that it was right up my alley because I'd been on boats every summer *and* they had a nice basketball team up there." He graduated as a marine engineer and as an ensign in the U.S. Navy, subsequently serving aboard a tank landing ship in the Caribbean and later in the merchant marine service for American Export Lines. But being an engineer, McAllister discovered, was not for him. "I wanted to see where I was going," he says. After one particularly grueling trip when his ship experienced engine difficulties and he was belowdecks for almost forty-five days in a row, he'd had enough.

To everyone's amazement, McAllister decided to start over as a deckhand and work toward his mate's license. His father, impressed if somewhat non-plussed, arranged for him to get as much experience as possible on different classes of boat in the family business, including the ferries that the company ran (and still runs) from Bridgeport, Connecticut, to Port Jefferson, Long Island. By the early 1960s McAllister had become a captain with more seagoing experience than anyone else in his family and was working as a docking pilot in New York Harbor. "I was single. I was living at home. I made a lot of money, and I had sports cars. I was living the good life," he recalls.

Around this time it became clear that his father and uncles wanted to sell McAllister Brothers, as the company was called then, and retire. This caused a problem for Brian and other members of the younger generation: If they wanted to stop the company from passing out of the family's hands and into a "Wall

Street outfit," they would have to come up with the money and financial expertise to take it over themselves. They found a solution in the form of a young Harvard Business School graduate named William Kallop, "a brilliant, just brilliant financial guy," McAllister says. "He knew all the tricks." In a deal of acrobatic daring, Kallop put together a successful bid of $20 million that required virtually no money down for his penniless investors; in 1974 Brian McAllister, along with two of his brothers and two cousins, became the fourth generation to own the family business, renamed McAllister Towing and Transportation. Once again, the family warning rang out: "Brian, this is the stupidest thing you've ever done. You'll never, ever make it!" Anthony duly informed his son, appalled at the debt he was taking on with no equity. McAllister laughs quietly at the memory, ruefulness mixed with pride. "He was almost right," he says.

Without anyone realizing it, New York Harbor had gone into an enormous post-war decline. Manufacturing was moving out, containerization was gaining momentum, and trucks were making greater and greater inroads into the transportation of goods. "The fact that we were in the process of going from 800 tugboats to 20 in this harbor was never apparent to us," McAllister says. "Nobody ever kept a record of how many were here, but it was just a constant, constant difficult business. It was like musical chairs, you know? You have twenty chairs, then you have nineteen, now you have eighteen. And somebody's got to sit down every time. But in an industry like this, you don't notice it."

In 1985 the collapse McAllister's father had warned of occurred when the world oil market crashed suddenly, sending the price of oil plummeting from about $40 a barrel to $7. For McAllister Towing, which had become increasingly involved in the oil field service business in the Gulf of Mexico, Saudi Arabia, Peru, and elsewhere, it was a disaster. Boats were tied up in their ports, men were laid off, and banks began closing in. The company was forced to sell off a number of vessels at bargain prices, an ironic inversion of the family's own practices after World War II.

Cheap tugboat labor also flooded New York Harbor, taking away important contracts from McAllister Towing, such as its city garbage-hauling contract.

The company had long been unionized, but attempts to negotiate with the union failed. McAllister and his fellow owners saw no alternative but to replace their employees when they went on strike. The decision was not made lightly: Memories of a brutal 1979 labor dispute (involving another towing company) in which nonunion crews had been assaulted were still fresh in everyone's mind. McAllister and the other managers who were qualified to captain tugboats left the boardroom for the pilothouses once more, at considerable personal risk—the son of one of their nonunion employees was shot at with a high-powered rifle, the bullet passing through the tug's windows and missing him by a foot. McAllister himself tried to purchase a gun for self-protection in Little Italy but found, to his chagrin, that he was not allowed to do so.

By 1991 it seemed that the company was back on course. Without union membership labor costs fell dramatically; the company managed to sell off much of its assets, and the banks ceased their circling— indeed, began eagerly offering credit again. In keeping with McAllister history, the family might have foreseen another convulsive bout ahead. The new trouble came in the form of a personal feud between McAllister and Kallop, the two remaining equal partners.

In 1974 Brian McAllister became the fourth generation to own the family business. "You'll never, ever make it!" his father warned.

It began innocently enough with a question from Kallop, about what McAllister wanted to do with the company now that it was once again prospering. McAllister, a tug lover to his very bones, replied that he'd like to fix up some of the boats in bad shape, give certain employees a raise, and generally "keep the flag flying." As McAllister recounts it, Kallop immediately jumped up and

shouted, "Brian! I went to Harvard Business School and Princeton before that, and I never, ever heard that the object of business was to *keep the flag flying.*" Bemused and a little hurt, McAllister had to go to his vice president for a translation. "It means, Brian, that he wants to sell," the VP told him gently. Some fifteen years later, McAllister still seems taken aback.

With McAllister firmly opposed to selling the family business, Kallop filed suit in 1993, claiming majority ownership. The subsequent battle for control, which in a Dickensian twist of plot came to hinge on the ownership of a disputed single share of company stock, became the talk of the industry. It was not resolved until 1995, when a court ruled in McAllister's favor. During the intervening years the two men, who continued to work in the same office, maintained an acidic silence. "Not a lot was said," is all McAllister will reveal of this time, his expression blank. A negotiated treaty between the two parties followed a couple of years later, with Kallop eventually taking control of the lucrative oil company and oil service operations (he moved to South America and later married a former Miss Peru) and McAllister retaining possession of what he still sees as the heart of his family's business: the ship-docking, tugboat, and barge-towing business. "Why would I want to own an oil company?" he asks simply.

"I could sell out tomorrow, except that I want to pass on something to the next generation."

Although McAllister may have been the loser in a strictly financial sense, he does not for a moment exude the air of someone who bears a grudge. There is plenty of work for his company "until long after I'm gone," he says, and he has had the infinite satisfaction of seeing his two sons and one nephew become the fifth generation in the family business (son Buckley is vice president and

general counsel, son Eric is vice president and treasurer, and nephew A. J. McAllister III is vice president of sales). Captain McAllister's sharp, focused attention is that of an active participant in his company rather than a mere figurehead.

Hurricane Katrina's disruption of the pipeline delivery of oil from the Gulf of Mexico hugely stimulated the need for tugboat transportation of foreign oil supplies. More long term, a number of liquid natural gas terminals are planned for the East and Gulf Coasts; along with its competitors, McAllister Towing is busy designing a new generation of the 5,000- and 6,000-horsepower behemoths capable of servicing these terminals. There's also the thriving ferry service to attend to—it now accounts for a quarter of the company's revenue. New York Harbor may no longer teem with tugs and barges as it did in McAllister's youth, but he is still in business more than 140 years after his family first arrived here, which is a remarkable victory in and of itself. "I could sell out tomorrow," he says, "except that I want to pass on something to the next generation." He pauses for a second. "That, and my wife would divorce me."

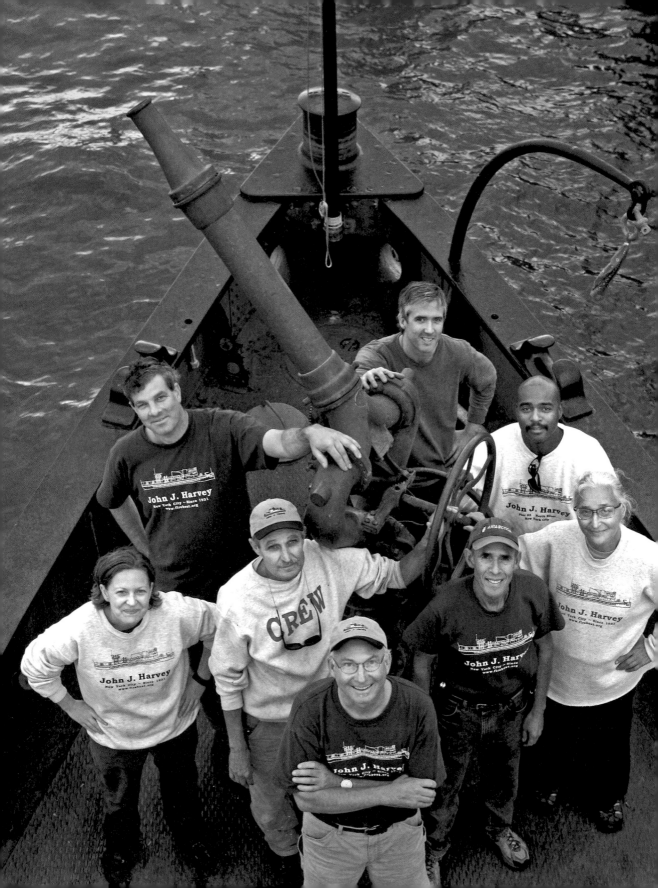

CREW OF *JOHN J. HARVEY*

Fireboat Preservationists

On a fall afternoon by the Hudson River at 23rd Street, a number of volunteers are gathered on the deck of *John J. Harvey*, an elegant former fireboat bristling with water cannons. The group digs with gusto into pizza and Sprite—their lunch, and the sole wages of their labors. Judy Finch, a slim, middle-aged woman with silver hair who exudes enthusiasm, sports a T-shirt that reads DIRTY WORK / LONG HOURS / NO PAY. She got it while helping restore another old boat, a nineteenth-century sailing vessel named *Wavertree* that belongs to the South Street Seaport Museum, but the same hard-headed appraisal clearly applies to her duties on board *Harvey*. Still downstairs in the engine room, immune to the prospect of sustenance, are Tim Ivory and Jessica DuLong, *Harvey*'s chief engineer and assistant engineer, respectively.

Harvey was the pride of the Fire Department of New York's maritime division in 1931 when she was built, easily outgunning and outmaneuvering the eleven other vessels in her fleet. Her rescue from scrapyard oblivion in 1999 by a bunch of self-confessed "boat nuts" is one of the more unlikely miracles to have occurred along New York's waterfront. Among a number of other historic vessels that have made the lower reaches of the Hudson their home in recent years—such as the 1907 ferryboat *Yankee,* the 1907 tugboat *Pegasus,* and the 1933 former lighthouse tender *Lilac*—*Harvey* is undoubtedly the best known to the general public. Painted bright red, and with her eight water cannons furiously pumping out 18,000 gallons of water a minute (enough to fill two swimming pools, *Harvey*'s Web site notes), she greets larger vessels coming into the harbor, such as *Queen Elizabeth II,* and takes schoolchildren and other groups on excursions around the city's various waterways and up the Hudson. On July

4 her cannons can be seen emitting great celebratory arches of water that form a fine miasma around her.

Huntley Gill, an architectural preservationist and one of *Harvey's* numerous co-owners (she was bought by a consortium of thirteen people), says that her public usage has been the key to her success. The boat is berthed at Pier 63 Maritime, a former rail-float barge owned by John Krevey, a man who might be said to maintain a maritime *salon.* Packed onto and around the barge are several historic vessels, a schooner, an old freight-train car, a kayaking group's storage facilities, a Hawaiian outrigger canoe, and a bar and cafe where carousing frequently transpires well into the night. If there's anything that Krevey enjoys more than old boats, it's letting the public have access to old boats, and so long as *Harvey* remains a resource for the public, he is happy to keep the rent to a minimum.

> Harvey's *rescue from scrapyard oblivion by a bunch of self-confessed "boat nuts" is one of the more unlikely miracles to have occurred along New York's waterfront.*

Gill, who likes to tell a good story, first met Krevey when Gill was looking for a home for another boat of his, a 1931 motor yacht that was slowly but inevitably sinking. "We went to see Krevey in about 1997," he recalls. "And he said"—Gill adopts a gravelly voice—"'Oh, no. I don't need any more boats. I've got this and I've got that. I've already got too many boats.' Luckily, we had a picture of her—she was a very sweet, wonderful old boat—and instantly John changed tack. He said, 'Okay, I think we can squeeze you in. I really ought to charge you $900 a month rent, but the pier's in really bad shape, so probably $650 would be better. But I'll tell you what,

until we fix the plates—$500 a month.' It was hilarious!" Gill laughs again in amazement at his good fortune.

It was Krevey who first found out that *Harvey* was for sale. She had been retired from service in 1995 and was sitting in the Brooklyn Navy Yard while the city prepared to auction her off. "We heard a rumor that somebody was going to bid $27,000, so we bid $27,010," says Gill. "Unfortunately, it turned out the next guy's bid was $10,600—*and* we had to pay sales tax on top of that." The boat's new owners were fortunate, however, in that they already had a berth for their purchase, courtesy of Krevey; the real problem lay in finding a crew to begin restoring her. Once again, Gill and his fellow owners were lucky. Ivory, a young marine engineer living on a former air-sea rescue boat on the Hackensack River in New Jersey, appeared and proved himself instantly and astonishingly adept at handling *Harvey's* phenomenally complex engine room, designed fifty years before he was born. "Tim was a godsend," says Gill. "He taught himself that engine room from top to bottom, inside out. It was really impressive." Ivory was soon offered a full-time paid job aboard *Harvey,* although, as Gill puts it, he's "really a volunteer," pointing out that Ivory makes at least a quarter less than he would working elsewhere.

Another crucial volunteer has been DuLong, Ivory's right-hand woman. DuLong, a journalist and psychology graduate of Stanford University, turned up at one of *Harvey's* public volunteer days and, despite her fancy education and pale Irish-Germanic complexion, immediately proved that she was made of the right stuff. "We went, 'Wow! This is our kind of woman,'" says Gill, who soon after offered her a "paid volunteer" position like Ivory's. Shortly afterward DuLong proceeded to buy her own ancient vessel, a broken-down 55-foot tugboat that she renamed *Gowanus Bay*—further proof of her maritime fortitude, if any was needed. On the trip back from Norfolk, Virginia, where DuLong purchased the boat, the engine cut out several times in the middle of a fierce storm in the Chesapeake Bay. The trip ended well, at least. "Jessica looked like she was about to *explode,* she was so happy as she steered it back into the harbor," says Gill, who smiles with the pure understanding of a fellow obsessive.

During the first year that Gill and his accomplices had possession of *Harvey,* they were being watched by a fierce and unhappy pair of eyes. The boat's former FDNY pilot, Bob Lenney, a man whose narrowed gaze and heavy jowls at times make him resemble an Al Hirschfeld caricature, was *Harvey's* captain for sixteen years before he reluctantly retired a year after she was taken out of service. "I think he saw a bunch of nitwits who were ruining his boat," says Gill, "and he was right. We had no idea what we were doing." Lenney, who leans against the window of the wheelhouse next to him, grunts in a way that confirms Gill's assessment, and Gill laughs happily. "The first time we saw Bob smile," Gill continues, "was when he came down to Caddell's"—a dry dock in Staten Island—"and saw that we had her up in the best and most expensive dock in the harbor. I think then he thought, 'Well, maybe things are going to be okay after all.'"

This time it's Lenney's turn to laugh, a grudging, throaty, suitably nautical rumble, as he turns from the pilothouse window through which he has been staring resolutely. Lenney, who lives in the "Irish Riviera" of Breezy Point, Queens, has since become an indispensable part of *Harvey's* operations, piloting the boat, or observing Gill's piloting, on many trips. Lenney's first time back at the wheel after retiring was a memorable one: It involved taking Gill and his unsuspecting crew on an impromptu tour of all three of the FDNY's marine divisions, culminating in a water-shooting display opposite Staten Island's Marine Company No. 9 firehouse in Stapleton, much to everyone's delight.

The event that brought *Harvey* most prominently to public awareness, however, was not a happy one. On September 11, 2001, when the World Trade

Center was attacked, Gill and the other owners immediately offered the boat's services, and he spent four days straight pumping water onto the devastated area around Ground Zero. With street access to the site entirely blocked and no water pressure available, *Harvey* performed an invaluable service and became, briefly, something of a national hero. The History Channel made a documentary about her life's exploits, and she was awarded a National Trust for Historic Preservation Award. Children's book author and illustrator Maira Kalman even wrote a book about her, entitled *Fireboat: The Heroic Adventures of the John J. Harvey,* which featured recognizable versions of Gill and his crew in action. (When the plane hit, Kalman reveals, Gill was reading *David Copperfield,* DuLong was writing a story, and Ivory was reading the paper.)

Gill, who normally delights in the absurd, becomes somber when he recalls those extraordinary hours. "It was like a scene out of Bosch. I've never seen anything like it in my life," he says. "But psychologically, we were in much better shape than a lot of other people because at least we had gotten to do something, and everyone else wanted to and couldn't. I think that was probably good for us." On September 12 DuLong arrived on *Harvey,* having persuaded the FDNY's marine division in Brooklyn to drop her off, as did Lenney, who managed to hitch a ride with a boat from Queens. For Lenney, the horror of the event hit especially hard, as he personally knew many of the firefighters killed in the attack, or, worse, was informed by others that their sons had died. Perhaps not surprisingly, he remains silent while the conversation turns to September 11. For Gill, the true strangeness of what had happened washed over him after his second night, when he left *Harvey* for a much-needed break and bicycled via Riverside Park to his home on the Upper West Side. "It was a beautiful, sunny day, and I felt like Alice in Wonderland," he says. "I stopped to buy a drink, and obviously I was looking like hell. Somebody stopped me and asked where I'd been, and I said, 'Down at the World Trade Center,' and they just went, 'Ohhhh . . .'" He smiles softly at the memory.

In the end, the events of September 11 turned out to be beneficial for *John J. Harvey* and for the other historic craft that cling, often uncertainly, to their

berths along the Hudson. The trustees of the new Hudson River Park—which has largely been a pedestrian-oriented affair to date, with its bikeways, jogging paths, and benches—have long been suspicious of such enterprises as old work-boats. As the de facto landlords of this section of the waterfront, the trustees have been reluctant to offer the boats any guarantees of long-term surety, or even to incorporate basic maritime facilities that might allow boats to dock around the park's perimeter. The danger of such a policy was clearly revealed on September 11, when there wasn't a single place to load or unload an emergency vessel any-where near the disaster site; boats had to either ram themselves up against the bulkhead full thrust or tie themselves to the few available trees, as did *Harvey*.

Like many waterfront advocates, Gill is hardly a fan of the Trust but says that he understands why it thought as it did. "When I first moved to the Village in the 1970s, there was a solid wall of pier heads, and I think it created this asso-ciation between boats and the working waterfront and this iron curtain," he says. "They saw boats as preventing access to the water. But now, thankfully, the argument is becoming a lot easier for us. There's a new generation."

Thanks to her fame, her dedicated crew, and the indefatigable Krevey, *Har-vey's* future is probably more assured than many of the vessels that make up this floating stretch of New York's maritime history. "I find it absolutely astounding that Krevey has actually been able to last," says Gill, "that he's *Krevied* the Hud-son River Trust. But it's that kind of creativity that used to be possible when the waterfront really was a waterfront, before you had parks run by lawyers." Like all old vessels, *Harvey* will probably always be short of money, her next overhaul always a matter of emergency. But the more she's out there—saluting ships, offering rides, being a living reminder of a more vigorous maritime past—the more likely she is to survive.

As the sky over the Jersey shoreline turns pale pink, then scarlet, Ivory and DuLong finally pop their heads into *Harvey's* spartan wheelhouse to say hello. The talk turns from the boat to their more personal loves, and photos are pulled from pockets. "Ah, she's *cute*," says Gill, examining a picture from DuLong. "Very cute." DuLong smiles and puts away the photo of her tugboat, *Gowanus Bay*.

STEVE KALIL

Dry Dock Company President

On the surface of it, Steve Kalil does not seem like a "waterfront guy." He is a lean, athletic-looking man in his fifties who dresses in suits, or—at his most casual—slacks, tie, and leather jacket. His office at the Caddell Dry Dock and Repair Company in West Brighton, Staten Island (founded in 1903 and thus one of the longest-running such companies in the nation), is so neat and characterless that it resembles a corporate showroom: The furniture is blond, the surfaces immaculate, the atmosphere muted. Only the view through the rear windows gives away the fact that Kalil is not an ordinary businessman. There, in panoramic fashion, a great tableau of maritime industry is laid out, as busy and complex as a Victorian narrative painting.

Each of Caddell's six huge, boxlike dry docks, which line the waters of this section of the Kill Van Kull along Staten Island's north shore, is filled with boats of various sizes; perched on wooden blocks, they resemble gifts in the process of being unwrapped. To the far right is the yellow bulk of the Staten Island ferry *John Noble;* to its left, and dwarfed by its presence, stand a couple of tugs—*Heidi Moran* and *Jill Reinauer,* their feminine names all the more touching amid such a masculine scene. On the wooden boardwalk that runs alongside the docks, there is a constant seething activity. Men in overalls and hard hats run this way and that, sparks fly from welding tools, and a giant crane lifts the mysterious innards of a tugboat through a hole cut in the top. In the spaces between the docks, the Kill slops green-gray.

"It's so satisfying, this kind of work, because you get to fix things," says Kalil. "It's not abstract like, 'My money just made money today'; it's real. Of all the different jobs available in this country, in very few of them do you get to see

Caddell's huge, boxlike dry docks are filled with boats of various sizes; perched on wooden blocks, they resemble gifts in the process of being unwrapped.

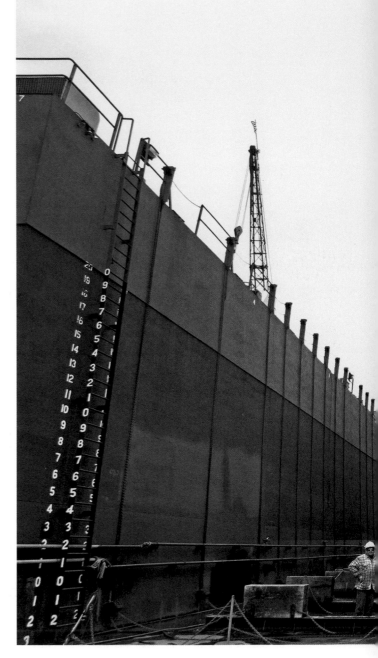

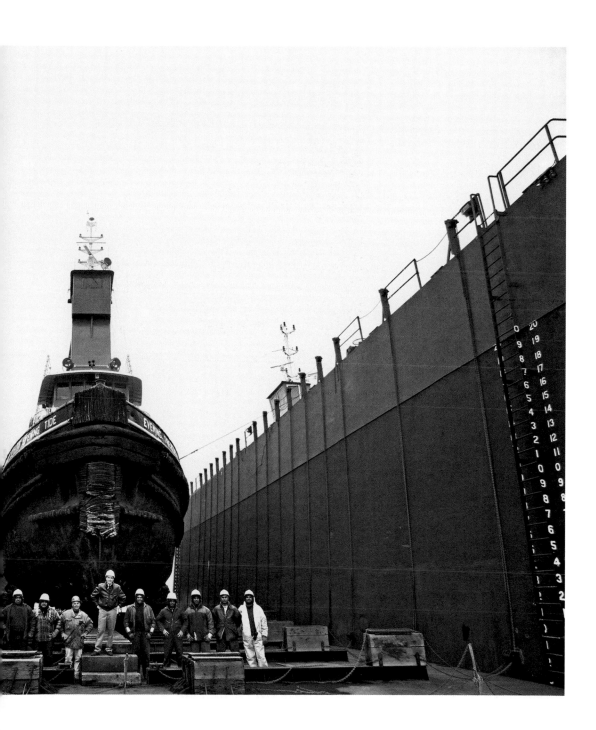

the fruits of your labor." Kalil has a right to talk about the satisfactions of labor, having started at Caddell in 1975 as a carpenter's helper. In addition to carpentry, he also helped with docking boats and doing the really dirty stuff, such as cleaning out fuel tanks and ships' bilges. Not only was it hard work, it was hard work done exposed to the elements: Temperatures reached more than one hundred degrees inside the bowels of a vessel in summer, and icicles formed on its exterior in winter. After a year Kalil decided that he'd had enough, but his boss, John Bartlett Caddell II, the grandson of the man who founded Caddell Dry Dock, saw prospects in his young hire and arranged to have him transferred to an office job. Kalil points out amusedly that there was no office for him to go to; he was allocated a desk that sat in the hallway for a year.

Today, in his role as company president, Kalil oversees about 300 boats a year that come through Caddell and is responsible for juggling a complicated schedule. Some of the boats come in for the equivalent of a fender bender, meaning that the sculptural stacks of rubber (usually made from refashioned truck tires) bolted to their sides need to be repaired or replaced, which can be done in a matter of days. Most, however, require more extensive repairs, such as rebuilding their "wheels" (as ships' propellers are known) or major work on the engines and shafts, and these procedures can take up to a couple of months. "There's no real average job time," Kalil says. The only thing each job has in common is that every owner wants to get his or her boat operating again as quickly as possible. This is particularly true for tug operators, as their boats tend to work twenty-four hours a day, seven days a week. Caddell is one of the last of the full-service dry docks left in the New York area, in that it offers everything from mechanical and structural to electrical repairs and maintains a large number of work gangs—nine in all—each specializing in a particular area such as pipe-fitting or welding. Altogether, the yard employs about 160 full-time workers and 100 or so subcontractors, making it the largest dry dock in the region and one of the area's biggest maritime employers.

Over the years, Kalil has seen several major cycles in the ethnicity of men employed at Caddell—the ripples of events played out on the world stage. When

he started at the company, most of the employees were "Squareheads," or Swedes and Norwegians, who served a good chunk of the maritime trades along the waterfront. Later, the workforce became predominantly African American (native Staten Islanders in particular), and more recently, the makeup has become Dominican and Central American. "It varies over time," Kalil says of his changing personnel. "I understand that a lot of Mexicans have started coming into the business, so that might change a lot over the next few years. There are a lot of shipyards in Mexico, so they come here with a lot of the skills already."

The men, who shout to each other in a pleasing mixture of Spanish, Italian, and blue-collar Brooklyn accents, work according to a "whistle system," a time-honored way of organizing the day. At 7:30 A.M. a whistle blows to start the workday; two more sound at 11:20 and noon to signal lunch and then a return to work, respectively. At 3:50 P.M. the fourth whistle blows for cleanup time, followed by the final whistle at 4:00 P.M. to end the day—though Caddell has been so busy of late that a large number of employees often remain to work overtime. This plenitude of work is due in part to

Kalil oversees the repair of about 300 boats a year. The only thing each job has in common is that every owner wants his or her boat operating again as quickly as possible.

the recent sharp decline in shipyard numbers in the Northeast and in part, Kalil says, to the modern urgency that has overtaken even this traditional business. "At one point you had slow periods during the summer, when all the port engineers took their vacations, and you had slow periods in winter, because of holidays and the extreme temperatures. But that doesn't seem to be the case anymore. All our

customers are busy, and busy year-round. They want to get in, get it fixed, and get back out."

The dry docks at the center of the Caddell company are remarkable creations, simultaneously imposing and extremely simple in construction. Kalil affectionately reels off the dates of their construction: this one in 1926, that one in 1942, that one in 1988, another one in 1980. The two oldest docks, dating from 1926 and 1942, are built of vast wooden timbers of longleaf yellow pine; Kalil says the trees were already 400 to 500 years old when they were cut down and points out that they were "so full of pitch, they'll never rot. The steel bolts will rot out first. And worms can't eat them, so they're basically as good as new."

Although shipbuilding technology has changed considerably over the years, with the increasing use of computer-controlled propeller and rudder systems, dry dock technology has remained constant. "It's been around since Egyptian times," says Kalil. "It's exactly the same thing." Unlike a graving dock, which is a vast basin dug into the ground that has to be flooded and drained over a matter of hours, a dry dock is essentially just a box along the water's edge that can be pumped out and raised in a matter of forty minutes or so. The boats at Caddell sit on carefully positioned wooden blocks, nicked and scraped and splashed with swaths of black and oxblood-red marine paint. Underfoot, a gritty metallic powder crunches satisfyingly, the residue of various weldings and scrapings.

As well as scheduling the complex comings and goings of so many vessels, Kalil, like everyone else involved in the working waterfront, must contend with ecological issues. The Kill is freer of sewage than it has been in more than a hundred years, but chemical contamination—or at least the perceived threat of it—has become the "bane of our existence," Kalil says. "Back when I started here, it was dead. I mean *dead*. No crabs, no worms, no fish—nothing. Now we're teeming with wildlife out there, and that's a wonderful thing. The problem is that ecological pressure for testing has become totally crazy." His voice remains calm and businesslike, but a steely edge enters into it, making it obvious that this issue agitates him greatly.

Over the years, federal requirements for testing dioxin, one of the princi-

pal forms of chemical contaminant in New York's waters, have increased from one part per million to one part per billion to one part per trillion. Kalil utters the word *trillion* with an air of amazement: "I mean, if you have a white shirt, there's more dioxin in that because of the bleach than a part per trillion," he points out indignantly. The cost for such stringent testing must be borne by the waterfront businesses being evaluated. With a grain of weary amusement, Kalil describes the process whereby mud from the Caddell waterfront is scooped up and a number of aquatic life-forms, from shellfish to microscopic organisms, are added and left for ninety days. After that they are tested to see if they're still alive and then freeze dried, ground up, and examined for contamination at the cellular level.

Caddell recently carried out four such tests, at a cost of about $50,000 per test; so far the company has passed muster. What really concerns Kalil, however, is that should the tested mud be found to exceed the dioxin limit, it might have to be shipped to a special upland mud dump at a cost of $55 per cubic yard, instead of being dumped at the official ocean burying site, 6 miles off Sandy Hook in New Jersey, at a fraction of the cost. "Now we're talking $13 million just to get rid of mud!" he says. "A company like this could never afford that much. I'd have to charge $200 an hour. It's insane."

Kalil and the Caddell family have other things to worry about, too. In the corridor behind Kalil's office is an ominous list of dozens of dry docks with the word CLOSED stamped in red ink across all but one of the names. "The year

> *In the corridor behind Kalil's office is an ominous list of dozens of dry docks with the word* CLOSED *stamped across all but one of the names.*

2005 was a shipyard disaster," Kalil says. "Tri-State"—a dry dock in Perth Amboy, New Jersey—"was forced out, and so was Gallagher's over in Brooklyn. We almost lost Union, in fact, but the deal fell through at the last moment. I really genuinely don't wish this, because you need to have competition, but if things head in the same direction, we could end up being the last shipyard around." The cause of most of these closures has been the rapidly escalating value of real estate and the pressures on dry docks, which sit on premium waterfront land, to sell in favor of residential development.

The City of Perth Amboy, which has a lavish, $600 million residential and commercial development plan that includes at its epicenter all twelve acres of Tri-State's venerable site (like Caddell, the business had been operating for more than a century), put enormous pressure on the company to sell. The equally historic New York Shipyards in Red Hook, Brooklyn, also folded under pressure, selling out to IKEA, which intends to build a big-box location on the premises. Union Dry Dock in Hoboken, New Jersey, was on the verge of signing a major deal with a real estate developer in December 2005; the agreement fell apart at closing, but it seems likely that the company's days are still numbered. Kalil is more sanguine about the future of his own company, partly because "it's hardly in a hot neighborhood," with the bleak, low-level sprawl of the West Brighton housing projects behind it and the sternly industrial view of Bayonne's oil tank farms across the Kill. But that, too, could quickly change, as Kalil is well aware. "If the gentrification from St. George starts coming down here—and it's pushing already—then it could happen, though I'd say we're somewhat protected for another 10 or 20 years or so," he says.

For now, though, this narrow stretch of water (and the Arthur Kill, its sister to the south) remains one of the busiest maritime areas in the world and seems likely to be so for some time to come, certainly for the duration of Kalil's career. Nearby is a cluster of maritime enterprises, including the Moran and McAllister tugboat companies, both major clients of Caddell; transport companies like Bouchard and Reinauer; plus fuel supply vessels, dredging platforms, oil barges, and the vast Howland Hook container terminal on Staten Island's

northwest edge, with all its attendant service industries. From Kalil's office, above the blunt forms of the dry docks, a steady procession of working vessels determinedly crisscrosses the water. Attached to the top of an enormous crane, an American flag flaps defiantly against a pale gray sky as the crane's arm moves languorously above the tugboat below, readying itself for action.

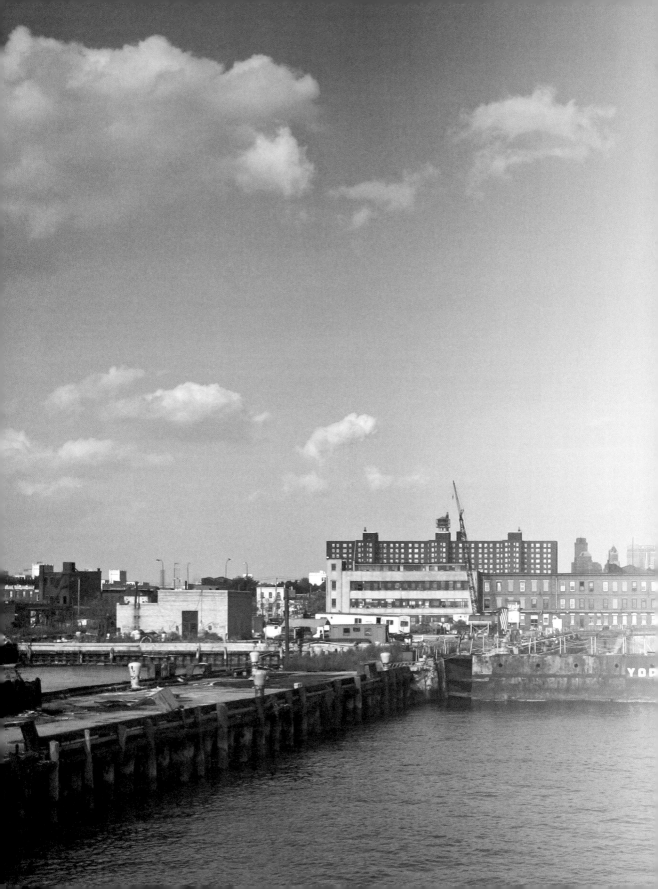

INDEX

ABOUT THE AUTHOR

Author **Ben Gibberd** is a British
writer and journalist who has lived
in New York for the past fifteen
years. He is a regular contributor to
the Sunday *New York Times*'s City
section with profiles, essays, and
news stories, and he writes about
Long Island for its In the Region
section.

Gibberd has written about
New York City for *Time Out London*
and *Time Out New York* magazines,
and his guidebook to Manhattan
was published by Peter Pauper Press in March 2006. He lives in Brooklyn with
his wife and their young son.

ABOUT THE PHOTOGRAPHER

Photographer **Randy Duchaine** enjoys the challenge and variety of working with a range of clients, from advertisers, multinational corporations, and design firms to editors and publishing houses.

Duchaine earned an associate's degree in liberal arts along with a bachelor's degree and honorary master's degree in photography from Brooks Institute of Photography. He has taught, lectured, and given seminars at Brooks, the Fashion Institute of Technology, Public School 51 in Brooklyn, the Brooklyn Botanic Garden, and other arts institutions.

The recipient of a Maggie Award (from the Western Publications Association) and a Desi Award, Duchaine also has won awards from the New York Art Directors Club, the Connecticut Art Directors Club, the Society of Publication Designers, Graphic Design USA, *Graphis,* and *How* magazine, among others. His work has been featured at numerous gallery shows.

Duchaine has been affiliated with the American Society of Media Photographers, the American Society of Picture Professionals, and the Advertising Photographers of America, and he currently is a board member of Photographic Arts Incorporated. He lives in Brooklyn.